CHICAGO'S WRIGLEY FIELD

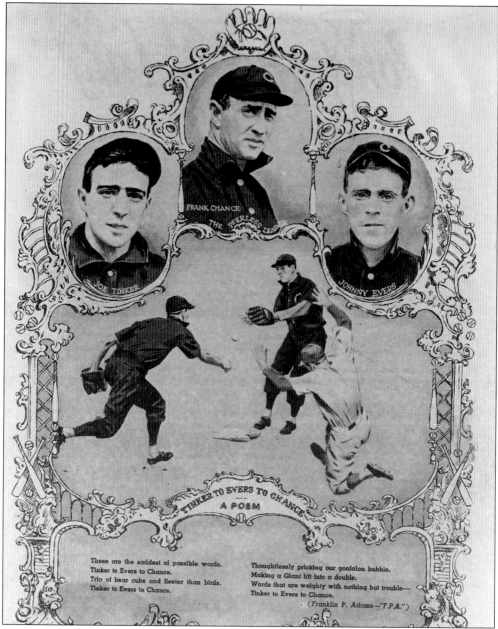

TINKER TO EVERS TO CHANCE
—
A POEM

These are the saddest of possible words,
Tinker to Evers to Chance.
Trio of bear cubs and fleeter than birds,
Tinker to Evers to Chance.

Thoughtlessly pricking our gonfalon bubble,
Making a Giant hit into a double.
Words that are weighty with nothing but trouble—
Tinker to Evers to Chance.
(Franklin P. Adams—"F.P.A.")

Long before Wrigley Field took its place in the annals of baseball stadium history, a New York newspaper columnist named Franklin Pierce Adams immortalized Chicago Cubs infielders Joe Tinker, Johnny Evers, and Frank Chance in a 1910 short verse poem entitled, Baseball's Sad Lexicon—Tinker to Evers to Chance. The "trio of bear cubs" formed the most memorable double-play combination in baseball history against their National League rivals, the New York Giants, and were instrumental in leading the Cubs to four National League pennants (1906–1908, 1910) and two World Series wins (1907, 1908). Although second baseman Johnny Evers and shortstop Joe Tinker formed a lethal combination on the playing field, the two athletes reportedly had a falling out early in their careers and didn't speak to each other again until the 1930s. (Photograph courtesy of Baseball Hall of Fame Library, Cooperstown, N.Y.)

CHICAGO'S
WRIGLEY FIELD

Paul Michael Peterson

Published by Arcadia Publishing
Charleston SC, Chicago IL, Portsmouth NH, San Francisco CA

Printed in Great Britain

Library of Congress Catalog Card Number: 2005920109

For all general information contact Arcadia Publishing at:
Telephone 843-853-2070
Fax 843-853-0044
E-mail sales@arcadiapublishing.com
For customer service and orders:
Toll-Free 1-888-313-2665

Visit us on the internet at http://www.arcadiapublishing.com

This book is dedicated to Joan…you are my every inning…

CONTENTS

Acknowledgments

No one person ever authors a nonfiction book without the help of others. The journey in composing this piece was punctuated by the willingness and generosity of many people and institutions who unselfishly offered their time, expertise, and resources in helping this work come to fruition. For those who informed and contributed to *Chicago's Wrigley Field*, whether by offering photographic ephemera or much-appreciated moral support, I would like to thank: April Armer, Arthur Bailey, Linsey Biewer, Brian Bowers, Bruce and Joan Bowers, Bruce and Cheryl Bowers, Joan Bowers (thank you for being my bride…), Kathleen Bowers, Michael Bowers, Steven Bowers, the late George Brace, Mary Brace, Lou Cella, Sam Dardick, Britney Lubera, Holly from Murphy's Bleachers, Tyler Jason, Ryan Jeffery, Steve Levenson, Jackie and J.B. Lorenty, Britney Lubera, Joe Mantegna, Jenni and Scott Maschmann, Matthew Markunas, Ron Nelson, Garrick Patten, Bruce and Sharon Peterson, David and Beth Peterson, Alex and Nicole Peterson, Christine Pundavela, Ward Tannhauser, Mrs. Mary-Frances Veeck, Michael Veeck, Santos Villareal, Kaliq Woods, Steve Wolf, and all the guys at Wolf Camera in Skokie, Illinois.

Special thanks to: the late Gail Albracht, a phenomenal teacher who instilled within me a love of writing; Rahan Ali, whose friendship means more to me than he can imagine; W.C. Burdick, of the Baseball Hall of Fame and Museum in Cooperstown, N.Y., whose patience and professionalism greatly contributed to this project; Joe Giuliani, editor extraordinaire, for taking a big risk on a self-taught reporter (I hope we can share a toast every Christmas); John Pearson, Jeff Ruetsche, and the entire staff of Arcadia Publishing who work thanklessly behind the scenes to make these books a reality.

Finally, my special thanks to you—the reader—for your interest in this text and your dedication to Chicago's favorite team. Cubs' fans are a special breed of individual, and it is my belief that your idealism and loyalty are the key ingredients that make Chicago a special place in which to live and a fun place in which to be a baseball fan.

INTRODUCTION

Wrigley Field is a Peter Pan of a ball park. It has never grown up and it has never grown old. Let the world race on—they'll still be playing day baseball in the friendly confines of Wrigley Field, outfielders will still leap up against the vines and the Cubs...well, it's the season of hope. This could be the Cubbies' year.
E.M. Swift

It should come as no surprise for visitors to Wrigley Field that Chicago's north side ballpark, which has experienced its share of "curses" and disappointments in the last nine decades of its existence, occupies what was once a Lutheran seminary. Despite myriad predilections toward the bad luck supposedly contained in Wrigley Field's environs, Cubs' fans consider this place to be holy ground and each year's journey to the intersection of Clark and Addison is a pilgrimage during a "season of hope"—a phrase so aptly coined by Swift in the quote above.

In a 1985 Esquire magazine article, the late journalism icon Mike Royko captured the aesthetic of Wrigley Field when he was quoted as saying, "Chicago is an old-fashioned, traditional American city, with subways and buses and neighborhoods with bungalows. The Cubs and Wrigley Field represent something to hang on to." Two decades later, this quote still rings true.

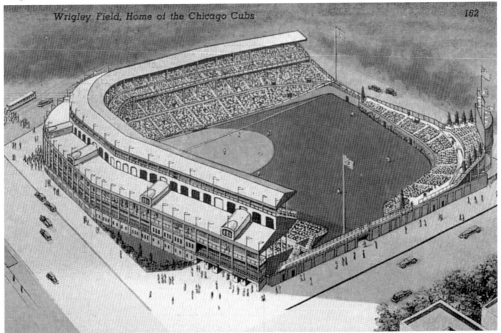

An early postcard of Wrigley Field from the late 1930s offers a clean architectural rendering of Chicago's neighborhood ballpark. (Photograph courtesy of author collection.)

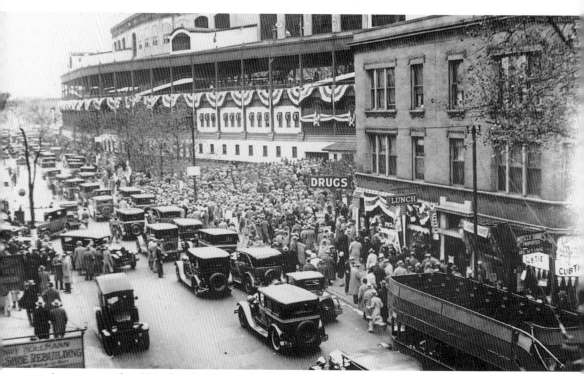

A scene outside of Wrigley Field circa the 1930s in which fans honeycombed the outside of the ballpark in hopes of catching an afternoon game. (Photograph courtesy Baseball Hall of Fame Library, Cooperstown, N.Y.)

ONE

Edifice of Beauty

The future of baseball is without limit. The time is coming when there will be great amphitheaters throughout the United States in which citizens will be able to see the teams that take part in the finest athletic struggles in the world.
Albert G. Spaulding, *Sporting Life*, 1908

Lunch counters, not chewing gum, built Wrigley Field. In 1892, at the age of 18, Charlie Weeghman arrived in Chicago and waited tables in a Loop restaurant. A short time later, the ambitious young man opened his own "dairy-lunch" counter with one-armed chairs that allowed customers the opportunity for fast service. After opening several more dairy-lunch restaurants, Weeghman became a millionaire and put his money in baseball.

When Weeghman formed the Federal League, the ball club was known as both the Federals and the Whales. Thinking his Chicago Federals—or "Chi-Feds"—needed a new park to afford the team greater credibility, Weeghman looked north to Clark and Addison Streets in a city that was not a North Side baseball town. What would later become a national treasure was built in only two months and opened on April 23, 1914; with a crowd of 21,000 (the park could officially hold 14,000) in attendance, the Chi-Feds defeated Kansas City 9-1 in spite of the raw wind blowing in from nearby Lake Michigan. "This great park," proclaimed Weeghman, "dedicated to clean sport and the furtherance of our national game, is yours, not ours."

After the 1915 season, the Federal League folded for financial reasons and Weeghman purchased the Cubs of the National League from the Taft family of Cincinnati. Weeghman then moved the Cubs to his two-year-old ballpark, where they remain to this day.

Wrigley Field is the second oldest ballpark in the major leagues, after Boston's Fenway Park, which was built in 1912.

Despite a few cosmetic enhancements and various structural changes over the years, today's Wrigley Field appears hauntingly similar to that of the early stadium. Spring weather in Chicago only teases Cub fans on Opening Day as pictured here during the 2004 season. (Photograph courtesy of author collection.)

New York's Polo Grounds Stadium was reportedly the model for Wrigley Field architect Zachary Taylor Davis, who had built Chicago's Comiskey Park only four years earlier. Mindful of the earlier wooden-built ballparks that had become fire hazards, Davis designed a one-story grandstand constructed of concrete and steel; he also planned for a structural capacity that could withstand the addition of an upper deck. (Photograph courtesy of author collection.)

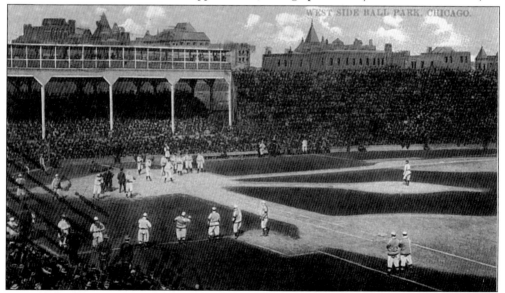

Meanwhile, Chicago's West Side Grounds was the precursor to Weeghman Park, which later became known as Wrigley Field. Occupying almost a square block and located two miles west of downtown Chicago, the first home of the Chicago Cubs held a capacity of 16,000 and was bounded by Polk to Taylor Streets on the east and Wood to Lincoln Streets on the west. The park first opened in May of 1893, and witnessed its last Cubs game in October of 1915. (Postcard courtesy of author collection.)

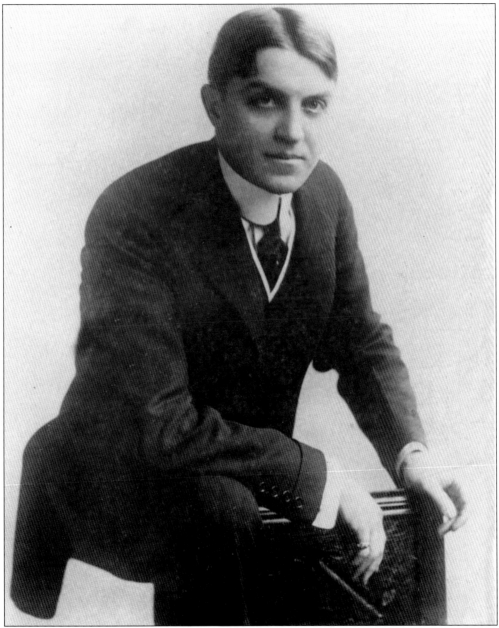

"Lucky Charlie" Weeghman, the true visionary behind what we know of today as Wrigley Field, hired Comiskey Park architect Zachary Taylor Davis to build an "edifice of beauty" on land once occupied by the Chicago Lutheran Theological Seminary. "Weeghman Park" was built at a cost of $250,000 over a two-month period and was immediately heralded as a ballpark masterpiece. Weeghman was the first to let fans keep foul balls, the first to initiate a weekly ladies' day, and the first to build concession stands in the park. Later, faced with mounting financial difficulties, Weeghman sold the team to chewing gum magnate William Wrigley, Jr., before leaving baseball for good. Charles Henry Weeghman, largely forgotten and abandoned by Chicago's baseball establishment, died of a massive heart attack in Chicago's Drake Hotel on October 2, 1938. (Photograph courtesy of Baseball Hall of Fame Library, Cooperstown, N.Y.)

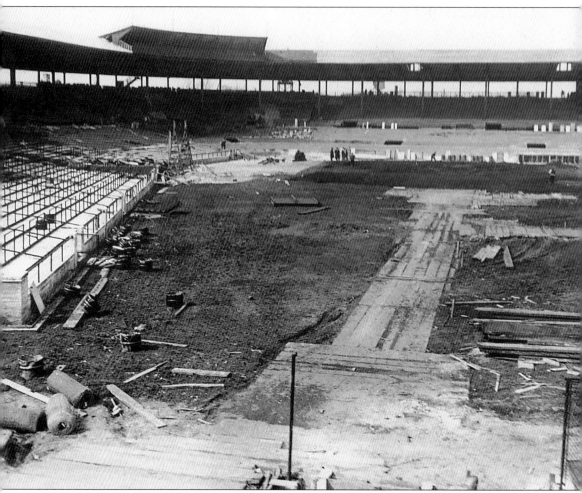

Charlie Weeghman's "edifice of beauty" took only two months to build. Construction crews razed the buildings at Clark and Addison Streets in February of 1914. Less than a month later, hundreds of construction workers laid acres of bluegrass sod and more than 4,000 yards of soil.

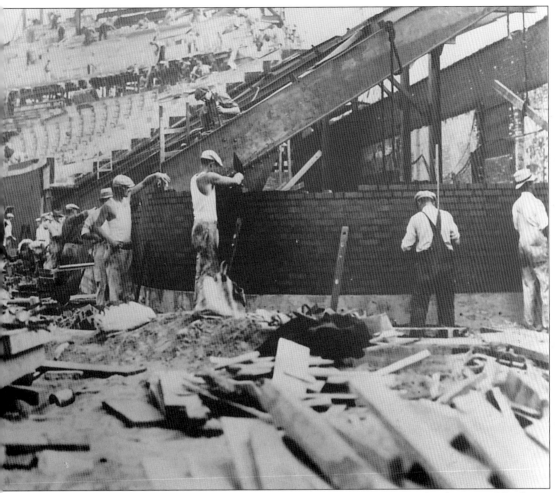

The famous address of 1060 West Addison Street is bounded by West Waveland Avenue, North Seminary Avenue, North Clark Street, and North Sheffield Avenue. (Photographs courtesy of author collection.)

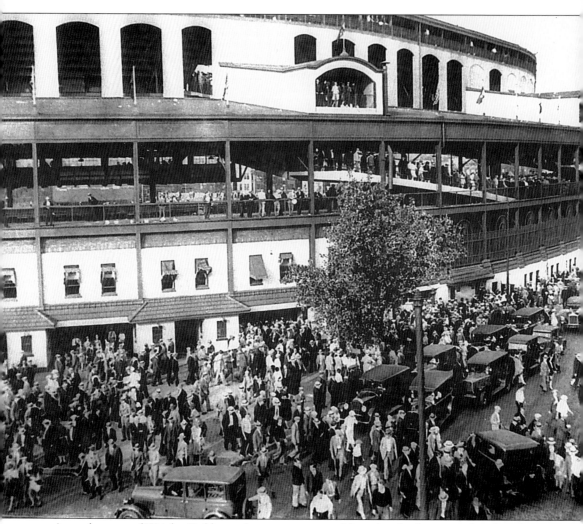

An early scene of Wrigley Field reveals a greater sense of formality for fans attired in their finest apparel for an afternoon at the ballpark. (Photograph courtesy of author collection.)

Two

From Weeghman to Wrigley

Baseball is too much a sport to be a business and too much a business to be a sport.
William Wrigley Jr. (1861-1932), Cubs Owner (1919-1932)

Arriving in Chicago from Philadelphia in 1891 with thirty-two dollars in his pocket, 29-year-old William Wrigley Jr. began his career as a door-to-door soap salesman before building a business empire with chewing gum.

Wrigley purchased the Cubs from Charlie Weeghman, renaming the ballpark "Cubs Park" in the winter of 1919, the same year that Baseball Commissioner Kenesaw Mountain Landis kicked eight Chicago White Sox players out of baseball for the alleged fixing of the 1919 World Series. Although he believed the team would continue to win pennants, Wrigley spent his first decade of ownership mired in frustration after hiring and firing several managers who were unable to produce the results he wanted for the team. Additionally disappointing were the attendance figures in the early to mid 1920s, which illustrated that the team—like the city itself—was in a state of transition.

And yet, Wrigley's business acumen would prove to be worthwhile in promoting the team during these lean years. In 1926, he hired new manager Joe McCarthy who buoyed the team's success by building a more powerful lineup that included Rogers Hornsby, Hack Wilson, Kiki Cuyler, Charlie Grimm, Charlie Root, and Leo "Gabby" Hartnett. After renaming the ballpark Wrigley Field in 1926, he began the traditions of discount tickets, promotions, and giveaways—all of which proved immensely successful. In 1927, attendance doubled, pushing the Cubs well over the million mark for the first time. In 1929, the team batting average was .303, one of the highest in major league history.

Meanwhile, the city outside of Wrigley Field's walls began to surge in population, business districts throughout the city had grown, and the entertainment and nightclub industries exploded as Al Capone and other gangsters enjoyed popularity and widespread publicity both inside and outside of Chicago's boundaries.

William Wrigley, Jr. watches a game between the Cubs and the Cardinals in April, 1930. Wrigley was a tireless promoter of the team from 1919 until his death in 1932. (Photograph courtesy of Library of Congress, Prints and Photographs Division LC-USZ62-103194.)

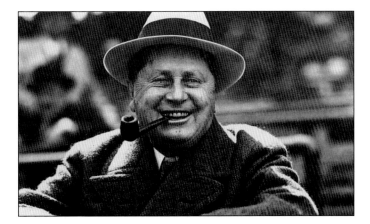

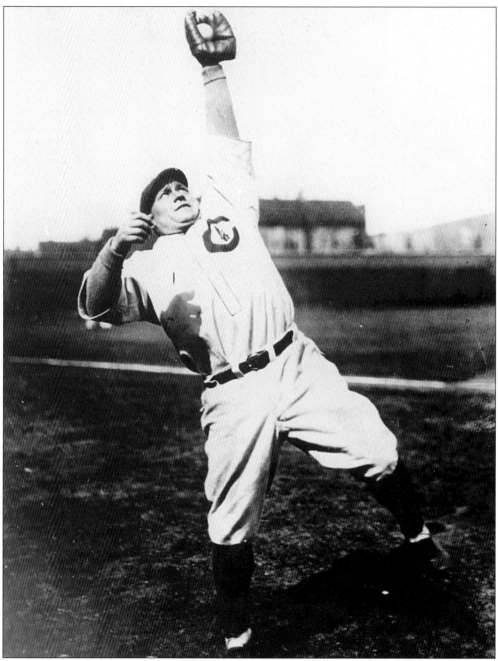

Lewis Robert "Hack" Wilson came to the Cubs in 1926 and in his six seasons with the ball club, he hit over .300 five times. At 5'6" and 195 pounds, Wilson's incredible power as a slugger resulted in 56 home runs during the 1930 season. (Photograph courtesy of Baseball Hall of Fame Library, Cooperstown, N.Y.)

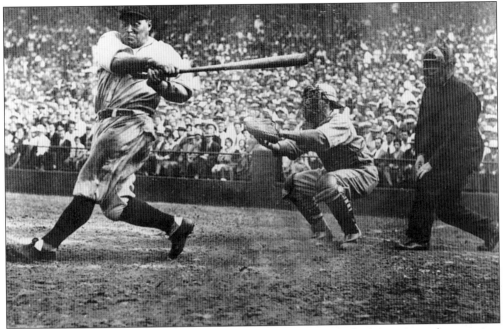

Hack Wilson assumes a powerful batting sense as his entire body contorts for a swing. (Photograph courtesy of Baseball Hall of Fame Library, Cooperstown, N.Y.)

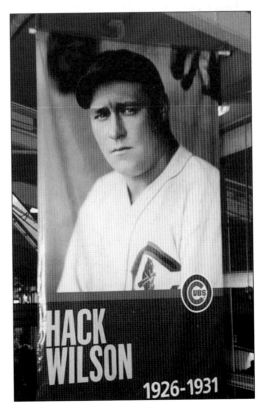

Even today, three quarters of a century after his last season with the Cubs, Wilson's banner can be seen hanging inside of Wrigley Field. (Photograph courtesy of author collection.)

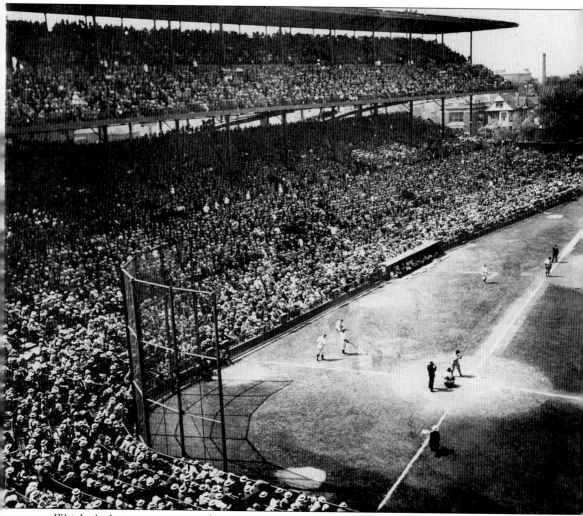

Wrigley's desire to promote the team combined with McCarthy's no-nonsense attitude as a manager increased game attendance significantly by the end of the 1920s. (Photograph courtesy of Baseball Hall of Fame Library, Cooperstown, N.Y.)

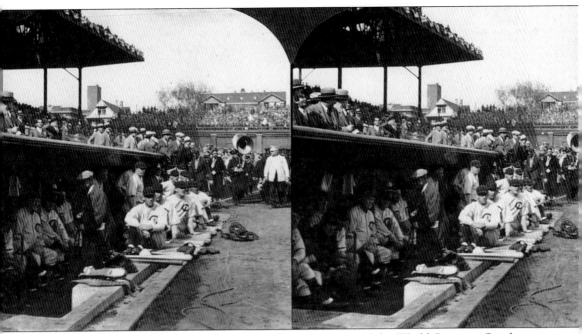

Cubs players wait in the dugout before the calling of a game of the World Series in October, 1929. (Photograph courtesy of Library of Congress, Prints and Photographs Division LC-USZ62-94924.)

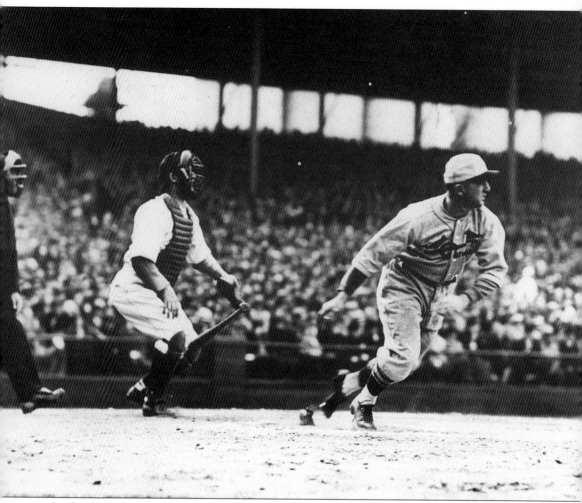

In the first game of the season on April 22, 1930, St. Louis Cardinal Frank Frisch acts on a swing as Chicago Cubs catcher Gabby Hartnett scans the oncoming play. (Photograph courtesy of Library of Congress, Prints and Photographs Division LC-USZ62-98156.)

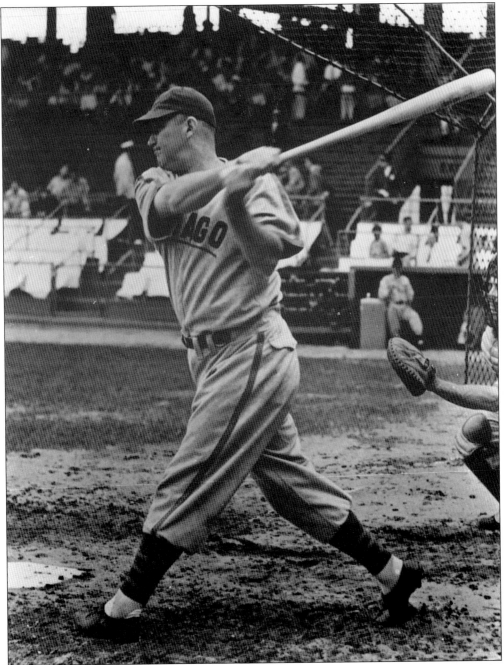

Catcher Gabby Hartnett, known as a quiet man, picked up the nickname "Gabby" from the fans. At 6'1" and 195 pounds, Hartnett hit a .297 lifetime and was famous for his "Homer in the gloamin'" on September 28, 1938, which gave the Cubs a 6-5 win against Pittsburgh en route to the pennant. Not one to lack confidence, Hartnett reportedly was quoted in 1937 by *The Sporting News* as saying, "Most catchers have to wear a mask because they're so ugly, but I have to wear one because I'm so pretty." (Photograph courtesy of author collection.)

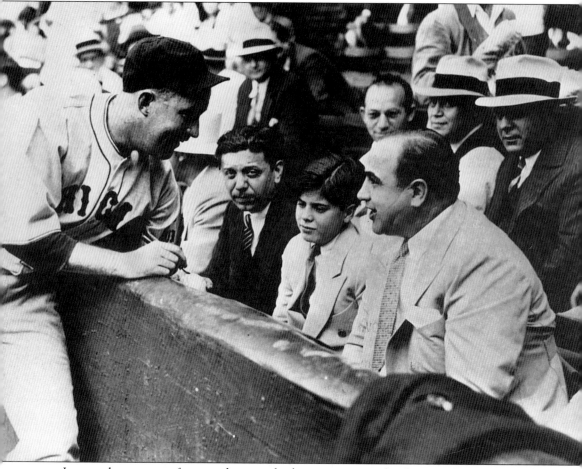

In a perhaps not-so-famous photograph that punctuates the "gangster" stereotype about Chicago, Gabby Hartnett autographs a baseball for Sonny Capone who is sitting with his father Al Capone and his father's other "associates" at a charity baseball game. Note the gentleman adorned in the white fedora directly behind Sonny with a maniacal smirk on his face. (Photograph courtesy of Library of Congress, Prints and Photographs Division LC-USZ62-124508.)

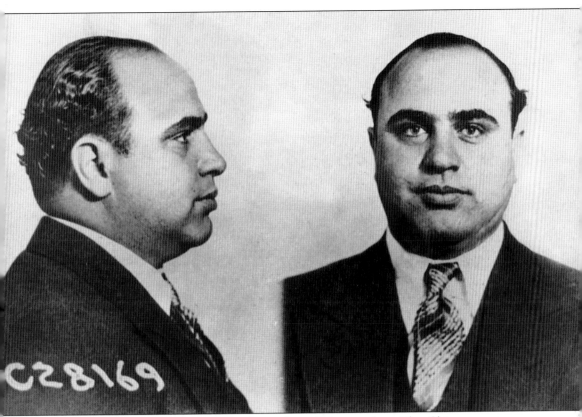

Al Capone (1899–1947) poses reluctantly in this 1931 mug shot. The Chicago gangster was notoriously known as the alleged mastermind behind the St. Valentine's Day Massacre of February 14, 1929, in which four Capone henchmen entered a garage at 2122 N. Clark Street—less than three miles from Wrigley Field—dressed as policemen, and fired 150 bullets into seven unsuspecting members of the rival "Bugs" Moran gang. (Photograph courtesy of Library of Congress, Prints and Photographs Division USZ62-123223.)

After Wrigley's death in January of 1932, son Philip Wrigley (known as "P.K." to his close friends) succeeded his late father as president of the Cubs. He was known to be generous with his players and former players, and was honest with print reporters—though he valued his privacy and did not grant radio or television interviews. (Photo courtesy of author collection.)

Wrigley Field underwent many changes under the direction of P.K. Wrigley, who carried on his father's tradition for making Wrigley Field a family-friendly and congenial place. P.K. Wrigley commissioned Bill Veeck Jr. to plant ivy on the outfield wall, which is noticeably absent in the photograph above. (Photograph courtesy of Baseball Hall of Fame Library, Cooperstown, N.Y.)

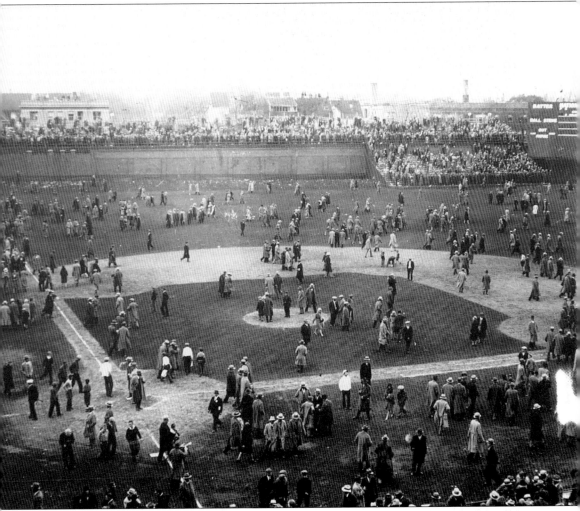

Can you imagine an era in which fans were allowed to mingle on the playing field immediately following an afternoon game? (Photograph courtesy of Baseball Hall of Fame Library, Cooperstown, N.Y.)

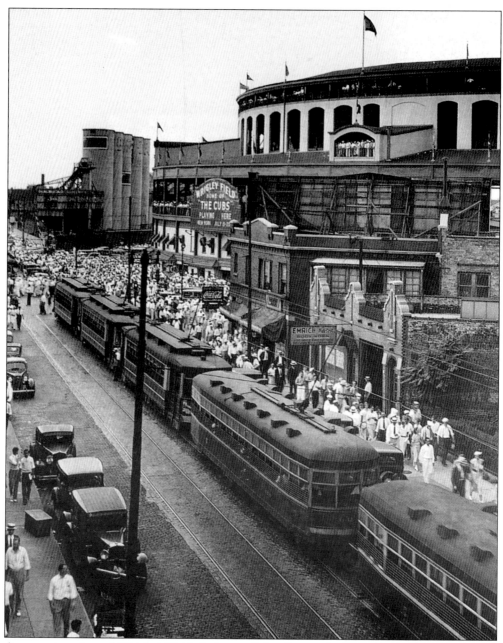

An exterior view of Wrigley Field during a Cubs–Giants doubleheader on July 21, 1935, highlights the realization that the disappearance of the once-ubiquitous streetcar has altered today's traffic patterns immeasurably. Veteran fans of the Cubs and current Chicagoans will testify to the excessive vehicle congestion one must face on a game day. (Photograph courtesy of author collection.)

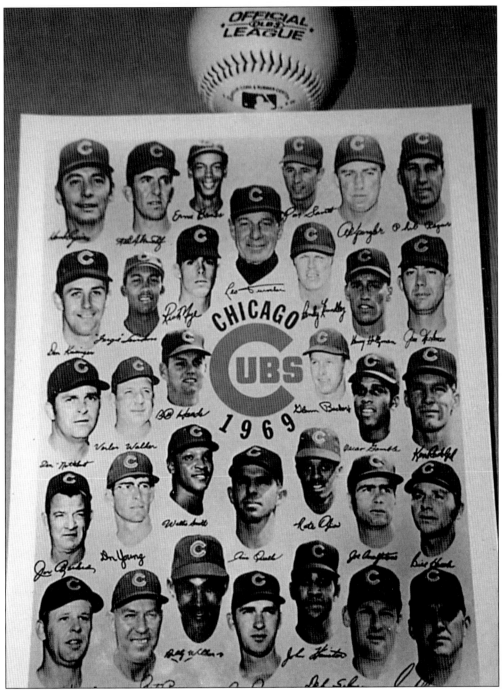

A group portrait of the 1969 Chicago Cubs illustrates a new era of players. In July of that year, Outfielder Billy Williams set a National League record for the most consecutive games played. Santo, Williams, and Jenkins led the Cubs to one of their most memorable seasons as Ernie Banks finished the decade with 269 homers. Although the Cubs of the 1960s and early 1970s were a talented group of players, the team never made it to the postseason. (Photograph courtesy of author collection.)

Ernie Banks, who delighted fans and players with his cheerful disposition and undying optimism, is famous for coining the phrase, "Let's play two!" Born in Dallas, Texas, on January 31, 1931, "Mr. Cub" played for 19 seasons with the Chicago Cubs before his last game in 1971. (Photograph courtesy of Baseball Hall of Fame Library, Cooperstown, N.Y.)

Ron Santo, who played for the Chicago Cubs from 1960 until 1973, hit 342 career home runs and is considered the greatest third baseman in Cubs' history. Known for his post-game ritual of clicking his heels together after a Cubs' win, Santo's victory dance was popular with the fans until the team stopped winning. Today, Santo is well known both as a Cubs' broadcaster and for his fundraising efforts for the Juvenile Diabetes Research Foundation. (Photograph courtesy of the George Brace collection.)

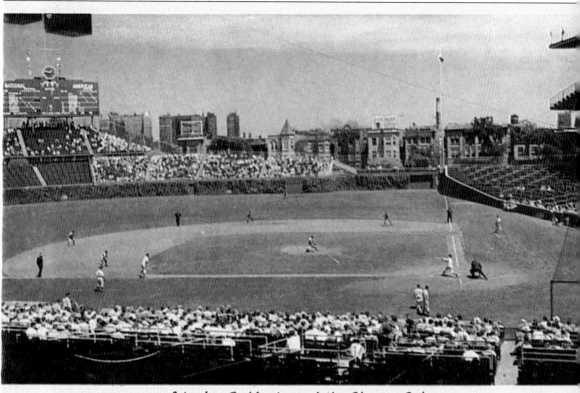

Wrigley Field Home of the Chicago Cubs

A postcard of Wrigley gives a view of the ballpark in the 1960s. (Courtesy of author collection.)

THREE

Bears at Wrigley

That last guy really gave me a good lick, Coach.
Bears rookie Bronco Nagurski to Coach George Halas after
hitting his head into a brick wall at Wrigley Field in 1930

George Halas knew a good thing when he saw it.

Long before the Bears took their name as the bigger brothers of the Chicago Cubs, the team was called the Decatur Staleys. Sponsored by A.E. Staley, the team was run by George Halas and his partner Ed Sternaman. In 1921, Halas and his partner brought the Staleys to the city where they would play in their new home at Wrigley Field after reaching a deal with then Cubs president, William Veeck Sr. (Halas later bought out Sternaman's share, assuming full ownership of the team in 1933.)

On Thanksgiving Day in 1925, the Bears enjoyed their first sellout with 36,000 fans at Wrigley Field in a scoreless tied game against the Chicago Cardinals. Halas, who was always trying to increase capacity at Wrigley Field, later installed temporary bleachers in the outfield and sold several thousand standing-room tickets. But despite such cramped conditions for football games, Wrigley Field hosted the Bears for half a century until the team outgrew the ball park and played their last game there in 1970.

Bronko Nagurski, a standout at the University of Minnesota, played fullback on offense and tackle on defense and was named an All-American. Nagurski later played for the Bears from 1930 until 1937, and came back for one season in 1943. In the 1930s, Nagurski scored a winning touchdown at the south end of the cramped field where the end zone was nine yards deep. After stomping on two opponents, Nagurski collided with a goal post and spun into the wall, where there remains a crack in the brick to this day. (Photograph courtesy of George Brace collection.)

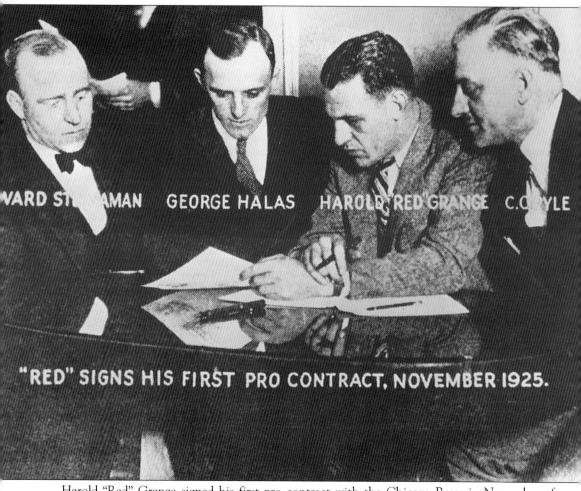

EDWARD STEINAMAN GEORGE HALAS HAROLD "RED" GRANGE C.C. PYLE

"RED" SIGNS HIS FIRST PRO CONTRACT, NOVEMBER 1925.

Harold "Red" Grange signed his first pro contract with the Chicago Bears in November of 1925. (Photograph courtesy of Pat McCaskey and the Chicago Bears.)

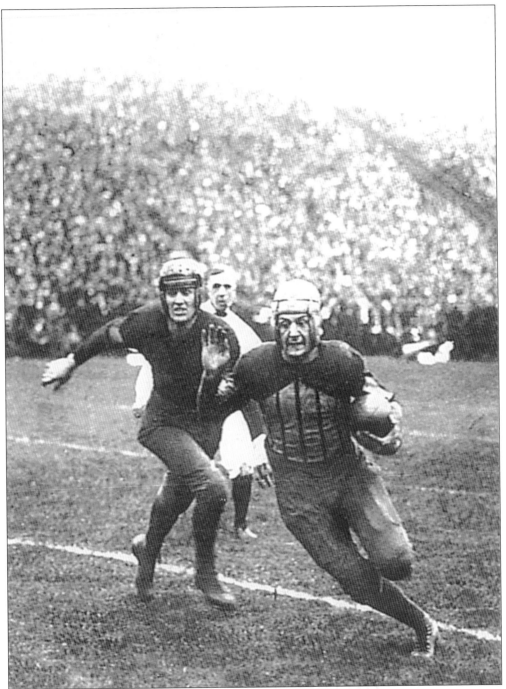

The legendary "Red" Grange is credited as the stimulus that boosted the N.F.L. into a recognized professional entity. In three seasons at the University of Illinois, Grange scored 31 touchdowns and rushed for 3,637 yards. He was named an All-American for three consecutive years, later drawing hundreds of thousands of new fans to football after signing with the Bears in 1925. In the era following World War I, people looked to athletes as larger-than-life heroes, with Grange as a prime example. (Photograph courtesy of author collection.)

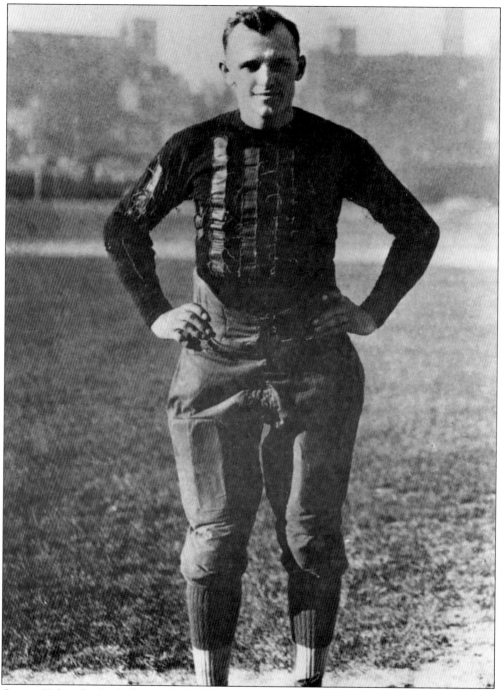

George Halas, the football pioneer who was a player-coach-owner of the Chicago Bears, was an innovator for professional football. He was the first to hold daily practices, the first to establish a preseason training camp, and the first to have his team's games broadcast on the radio. He coached the Chicago Bears for 40 seasons, was inducted into the Pro Football Hall of Fame in 1963, and won six championships as head coach. (Photograph courtesy of Pat McCaskey and the Chicago Bears.)

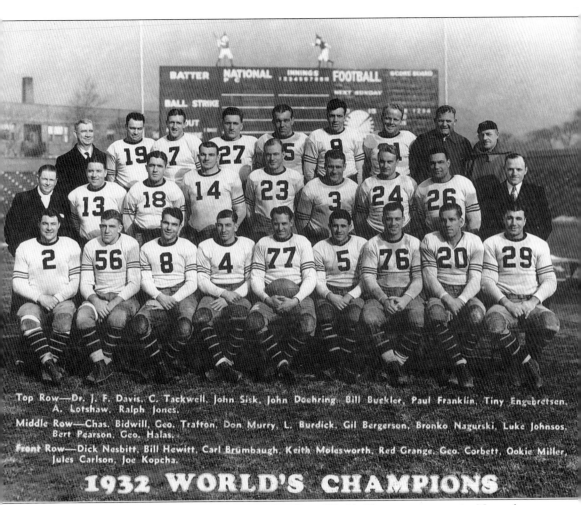

Top Row—Dr. J. F. Davis, C. Tackwell, John Sisk, John Doehring, Bill Buckler, Paul Franklin, Tiny Engebretsen, A. Lotshaw, Ralph Jones.

Middle Row—Chas. Bidwill, Geo. Trafton, Don Murry, L. Burdick, Gil Bergerson, Bronko Nagurski, Luke Johnsos, Bert Pearson, Geo. Halas.

Front Row—Dick Nesbitt, Bill Hewitt, Carl Brumbaugh, Keith Molesworth, Red Grange, Geo. Corbett, Ookie Miller, Jules Carlson, Joe Kopcha.

1932 WORLD'S CHAMPIONS

Members of the 1932 Chicago Bears pose for their World Champions portrait. Note the stickmen figures atop the scoreboard from Wrigley Field in the background. (Photograph courtesy of George Brace collection.)

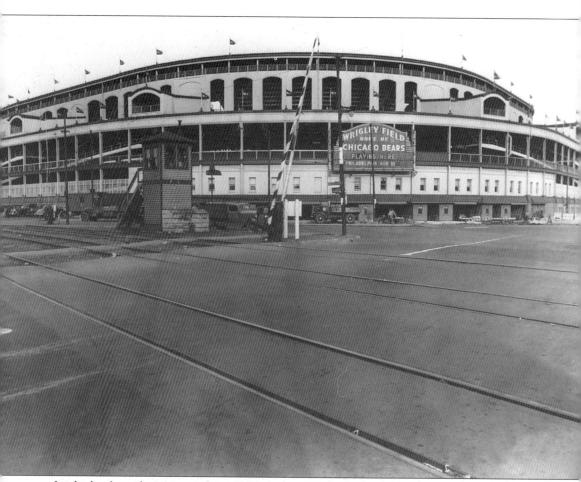

Look closely at this exterior shot of Wrigley Field and you'll notice that the sign says, *Home of Chicago Bears*. The team played in the "Friendly Confines" for half of a century. (Photograph courtesy of George Brace collection.)

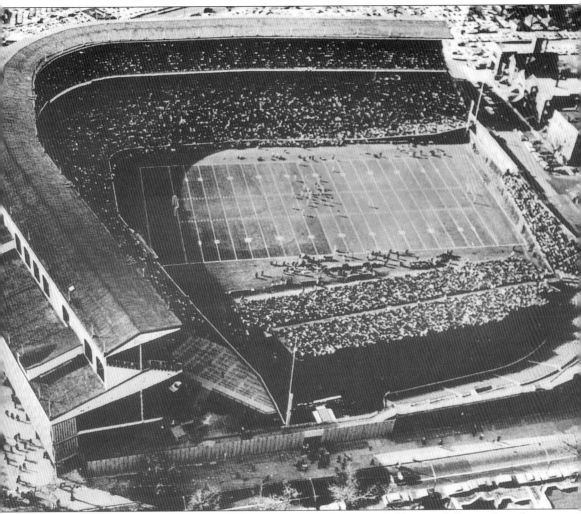

An aerial shot of Wrigley Field when the Bears played shows a field quite different than the one Cub fans are used to seeing. The field ran north-south, from the first-base dugout to the left-field wall. (Photograph courtesy of author collection.)

Bears Play 7 Games Here!

**Charity Battle vs. Giants Sept. 10—
Pro Grid Season Opens October 9**

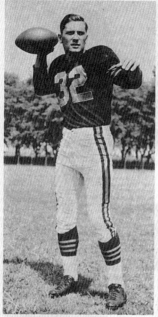

JOHNNY LUJACK

The Chicago Bears will battle the New York Giants on Saturday, Sept. 10 at Wrigley Field in the fourth annual Armed Forces Benefit football game. This game is under the sponsorship of the Chicago Sun-Times.

It will be Johnny Lujack versus Chuck Conerly in their renewal of the 1948 "Rookie of the Year" feud. In addition to seeing a standout football game, fans will witness a spectacular military pageant, with all branches of the services participating.

In addition to such outstanding veterans as Sid Luckman, Johnny Lujack, Bulldog Turner, George Connor, George McAfee and Ken Kavanaugh, the 1949 Chicago Bears will be fortified by a fine rookie crop. Some of the top new Bears now in training at St. Joseph's College, Rensselaer, Ind., include George Blanda of Kentucky, Bob Mitten of North Carolina, Bobby Barbour, the Little All American from Delta State; Wally Dreyer, Wisconsin, George Ben-

igni, Georgetown, and John Hoffman of Arkansas.

The Bears will play six league games on their Wrigley Field home gridiron, opening the season on the North Side on October 9 against the Los Angeles Rams. Other National league clubs to be seen in action here are the Philadelphia Eagles, Green Bay Packers, Detroit Lions, Pittsburgh Steelers and the arch-rival Chicago Cardinals.

Tickets for all games are now on sale at the Chicago Bears office, 233 W. Madison street. Box seats and East stand tickets are $4.00 per game, and grandstand is $3.00. By the season, the price for box seats and East stand tickets is $24.00, and grandstand is $18.00. All seats are reserved.

Following is the 1949 home schedule for the Bears:

*Sept. 10	New York Giants
Oct. 9	Los Angeles Rams
Oct. 16	Philadelphia Eagles
Nov. 6	Green Bay Packers
Nov. 13	Detroit Lions
Dec. 4	Pittsburgh Steelers
Dec. 11	Cardinals

*Armed Forces Benefit Game.

100,000 Boosters
See Cubs in 1949

The Chicago Cubs Junior Booster club, whose membership consists of the outstanding boys and girls of Chicago, completed its second year's activity this summer, distributing 100,000 free admissions to youngsters for Cub games at Wrigley Field.

The ambitious program was started last year, when 90,000 tickets were awarded youngsters on a merit basis, through the major youth-serving organizations in Chicago.

Each organization established a standard of merit for eligibility in the Cub Booster club. Youngsters who qualified were given a ticket to any Cub ball game scheduled during the summer vacation, and were also awarded a Booster club membership button.

The first organization of its type in baseball, the Cub Booster Club has been praised widely in baseball circles and among youth-serving organizations all over the United States. The Cubs expect to continue sponsorship of the Booster club next year.

Autographed Baseballs

Autographed baseballs, signed by members of the Cubs, are now on sale at Wrigley Field. The price is $2.00. Mail orders not accepted.

Bonus Ladies Day Scheduled with Brooklyn September 19th

The Cubs have designated Monday, September 19 as a special Ladies Day at Wrigley Field. The Brooklyn Dodgers are scheduled to play the Cubs on that date.

The Cubs added the special Ladies Day to their schedule to make up for turning away 10,000 Ladies Day fans from the game between the Dodgers and Cubs on July 28. The gates were closed shortly after game-time, because all grandstand and box seats were occupied, and it was impossible to sell standing room tickets to the large crowd outside the park.

Originally 14 Ladies Days were scheduled at Wrigley Field this year, with each team appearing twice for Ladies Day games. The July 28th game was the second scheduled. So September 19 will be the third and "bonus" Brooklyn-Cub Ladies Day game of the year, giving Chicago's feminine followers of the Cubs another chance to see the Dodgers.

One other Ladies Day game is scheduled before the season ends. The Boston Braves will be the attraction, meeting the Cubs in a Tuesday, September 13 Ladies Day battle.

All women and girls, 12 and over, are admitted to the game upon payment of the 25 cents federal tax, at Ladies Day Gate, Sheffield and Addison. Reserved box seat tickets can be purchased in advance at Wrigley Field and Lytton's downtown. The price is $1.00, including tax.

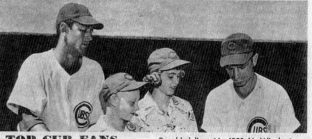

TOP CUB FANS . . . Ronald Julian, 11, 4203 N. Winchester and Judy Watkins, 13, 836 Forest, Highland Park, spend a day with the Cubs as one of their awards after being chosen the best Cub fans of the Chicago area in a city-wide essay contest sponsored by Pacific Mills, manufacturers of the popular Cub shirts for youngsters. Wearing their Cub shirts, Ronald and Judy are shown visiting with Roy Smalley (left) and Andy Pafko.

A vintage copy of the Chicago Cubs News from August of 1949 features an interesting brief about the Bears, including the home schedule for the season. (Courtesy of author collection.)

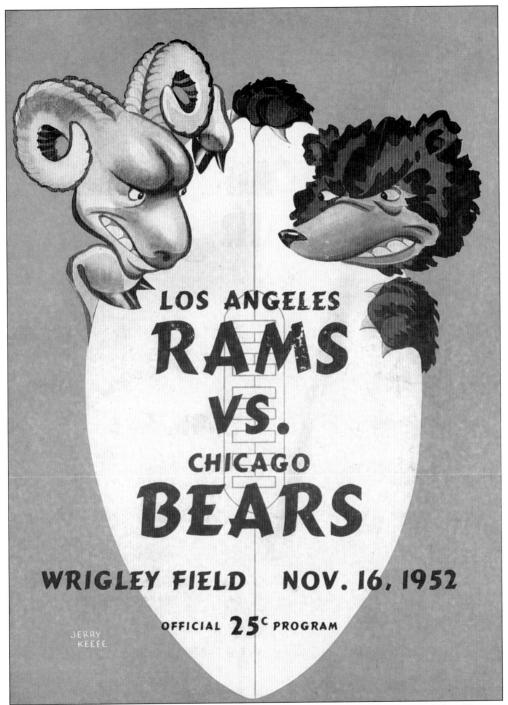

An early program advertises the 1952 battle between the Los Angeles Rams and the Chicago Bears. In 1950—just two seasons earlier—the two teams tied for the Western Division title. (Courtesy of author collection.)

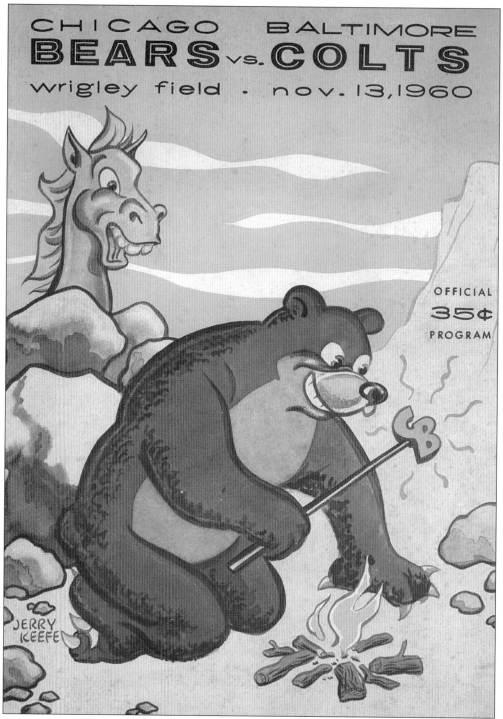

A program sample from 1960, the decade in which George Halas would retire after 40 seasons with the Chicago Bears.

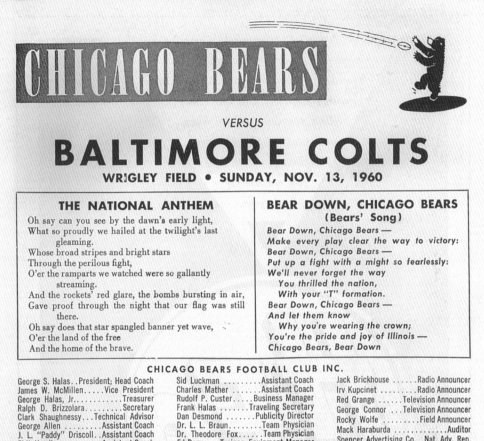

CHICAGO BEARS

VERSUS

BALTIMORE COLTS

WRIGLEY FIELD • SUNDAY, NOV. 13, 1960

THE NATIONAL ANTHEM

Oh say can you see by the dawn's early light,
What so proudly we hailed at the twilight's last
 gleaming.
Whose broad stripes and bright stars
Through the perilous fight,
O'er the ramparts we watched were so gallantly
 streaming.
And the rockets' red glare, the bombs bursting in air,
Gave proof through the night that our flag was still
 there.
Oh say does that star spangled banner yet wave,
O'er the land of the free
And the home of the brave.

BEAR DOWN, CHICAGO BEARS
(Bears' Song)

Bear Down, Chicago Bears —
Make every play clear the way to victory:
Bear Down, Chicago Bears —
Put up a fight with a might so fearlessly:
We'll never forget the way
 You thrilled the nation,
 With your "T" formation.
Bear Down, Chicago Bears —
And let them know
 Why you're wearing the crown;
You're the pride and joy of Illinois —
Chicago Bears, Bear Down

CHICAGO BEARS FOOTBALL CLUB INC.

George S. Halas . . President; Head Coach
James W. McMillen Vice President
George Halas, Jr. Treasurer
Ralph D. Brizzolara Secretary
Clark Shaughnessy . . . Technical Advisor
George Allen Assistant Coach
J. L. "Paddy" Driscoll . . Assistant Coach
Phil Handler Assistant Coach
Luke Johnsos Assistant Coach

Sid Luckman Assistant Coach
Charles Mather Assistant Coach
Rudolf P. Custer Business Manager
Frank Halas Traveling Secretary
Dan Desmond Publicity Director
Dr. L. L. Braun Team Physician
Dr. Theodore Fox Team Physician
Ed Rozy Trainer; Equipment Manager
Brundage & Short Attorneys

Jack Brickhouse Radio Announcer
Irv Kupcinet Radio Announcer
Red Grange Television Announcer
George Connor . . . Television Announcer
Rocky Wolfe Field Announcer
Mack Haraburda Auditor
Spencer Advertising Co . . Nat. Adv. Rep.
Lew Merrell Program Director

HILLISON & ETTEN COMPANY, CHICAGO 248

Represented for National Advertising by Spencer Advertising Company, Inc., 271 Madison Avenue, New York, N. Y.

Who today can imagine singing the Bears' song in Wrigley Field? (Courtesy of author collection.)

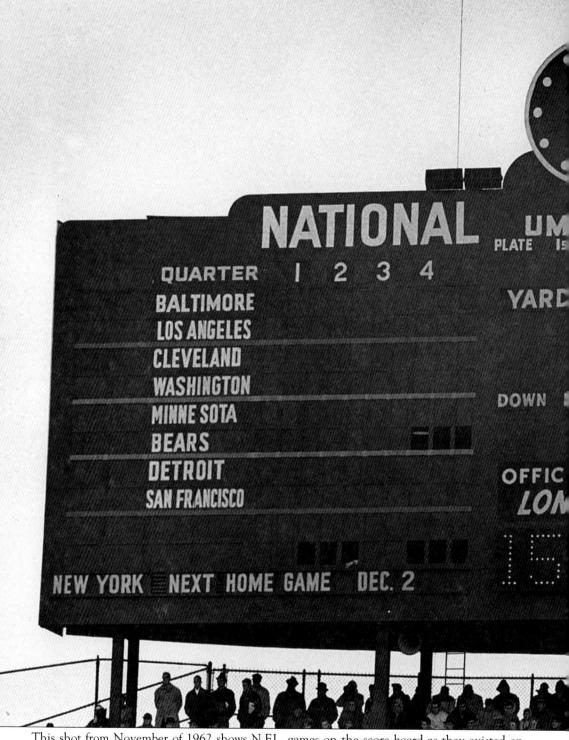

This shot from November of 1962 shows N.F.L. games on the score board as they existed on that date.

There were seven games that Sunday and only 14 teams in the league. (Photograph courtesy of Ron Nelson.)

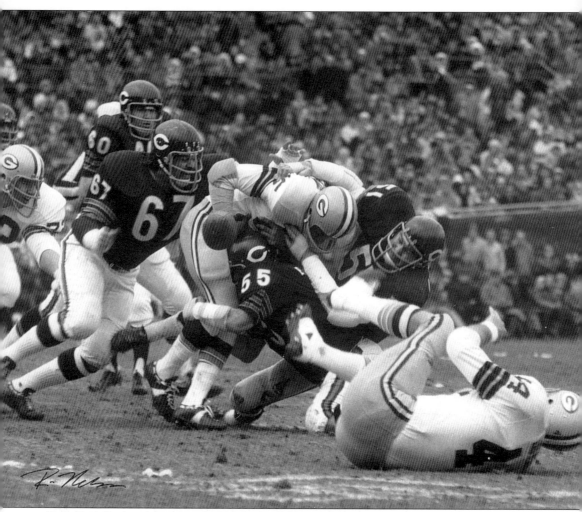

Both Dick Butkus (above) and Mike Ditka (facing page) were mainstays of the Chicago Bears during the 1960s era at Wrigley Field. As a 6'3", 245-pound middle linebacker, Butkus was a feared entity by the offensive players of the N.F.L. Meanwhile, at 6'3" and 230 pounds, Mike Ditka excelled as a tight end for the Bears from 1961–1972. Ditka later returned to coach the Bears to a 1985 Super Bowl championship. (Photographs courtesy of Ron Nelson.)

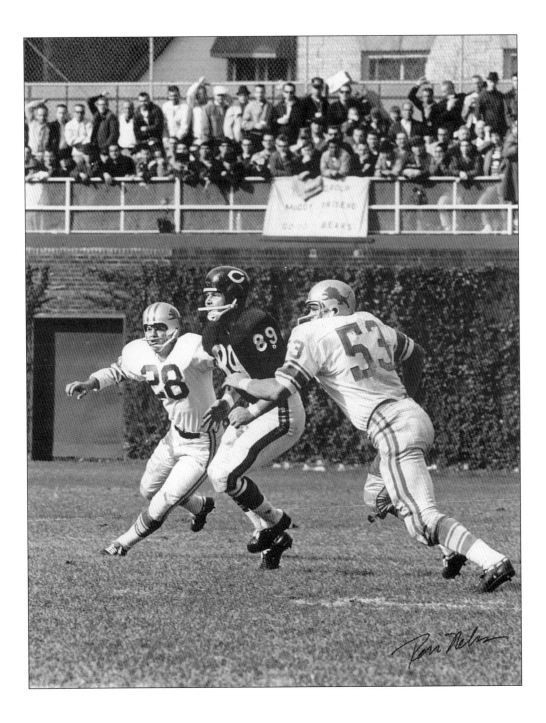

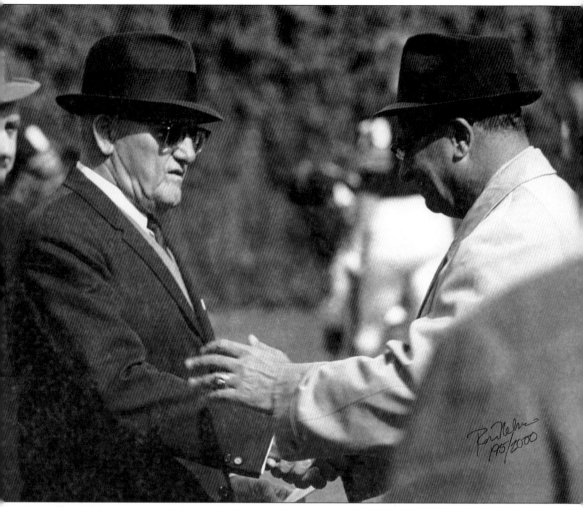

Two of the greatest coaches in football history meet before the 1963 Chicago Bear–Green Bay Packer game. George Halas and Vince Lombardi played to win and this photograph illustrates the high personal regard and respect they had for each other. (Photograph and caption courtesy of Ron Nelson.)

FOUR

Inside the Friendly Confines

The obvious occurred to me: That a ballpark is, first of all, a park. Looking over the outfield fences I saw a city neighborhood, but there, inside the boundaries, was parkland so beautifully tended and tranquil that it was almost jarring. No wonder so many people make a habit of going to baseball games even when their team is not doing particularly well.
Bob Greene, *Chicago Tribune*, 1981

How can a team that consistently loses continue to sell out its tickets season after season?

Wrigley Field possesses a magic in its environment that is unrivaled by any of the retro cookie-cutter venues that pay homage to concrete and advertising. Former Chicago Tribune columnist Jerome Holtzman summed it up best when he said: "All of the new parks were the same—Kansas City, Philadelphia, St. Louis, Cincinnati. If you've been to one, you've been to them all." Wrigley Field seems to be one-of-a-kind in offering fans what other ballparks cannot:

the close proximity of the seats to the field, the cozy neighborhood setting, the ivy, the manual scoreboard, and clean sight lines that don't impose a view of a parking lot.

The late Bill Veeck, who appreciated and contributed significantly to the aesthetics of Wrigley Field, believed in the individualism that a ballpark could offer. "If these parks go," stated Veeck in a 1985 article from *Baseball Digest*, "It won't be the end of Western civilization, but it will be one giant step toward the homogenization of all of us."

The old familiar marquis doesn't feign sincerity it when it says, *Welcome*. (Photograph courtesy of author collection.)

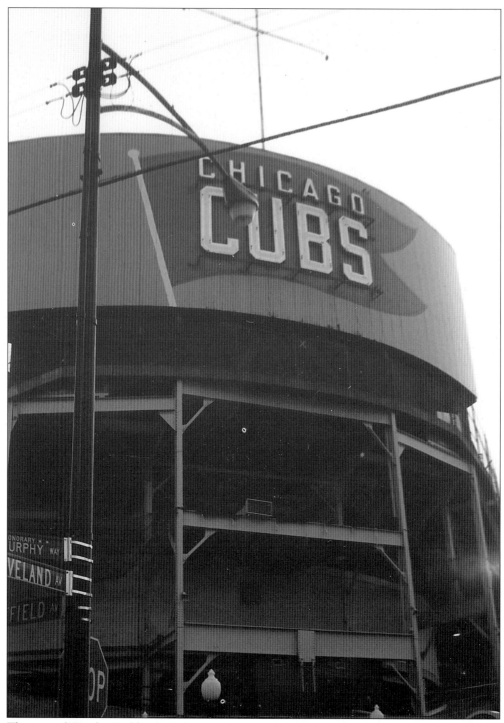

The rear of Wrigley Field, which lies at the corner of Waveland and Sheffield, is actually the only entrance point for the bleachers—a section all unto itself. The original scoreboard stands on the reverse of the painted flag with the neon Chicago Cubs lettering. (Photograph courtesy of author collection.)

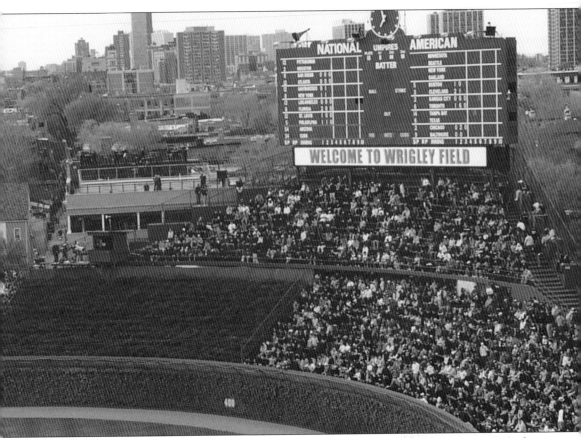

A flipside view of the opposite page photograph reveals the scoreboard, bleacher occupants, and beautiful green ivy. (Photograph courtesy of author collection.)

The intersections of Clark and Addison provide a casual meeting point for ticket holders and for spotting your favorite inflatable Harry Caray. Note the Cubby Bear bar on the southwest corner, a popular venue for both live music and pre-game parties. (Photograph courtesy of author collection.)

Wrigley Field is one of the ballparks that provides a formal bike check service for those commuters eschewing public transportation or the excessive costs associated with parking a vehicle on game day. (Photograph courtesy of author collection.)

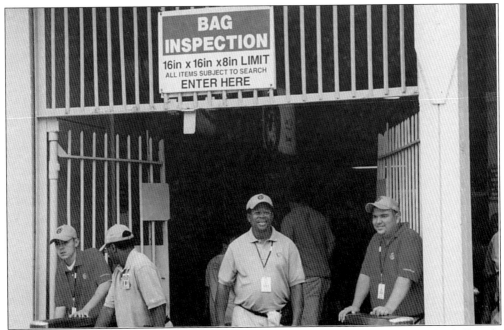

The need for increased security has resulted in fewer items being permitted in the ball park. Each entry gate at Wrigley Field has a designated bag search lane for all guests with items requiring inspection. Each entry gate also has an "express" lane for those guests not carrying items requiring inspection. Much like many other sports facilities, those attending the game are not allowed re-entry, even with a ticket stub. (Photograph courtesy of author collection.)

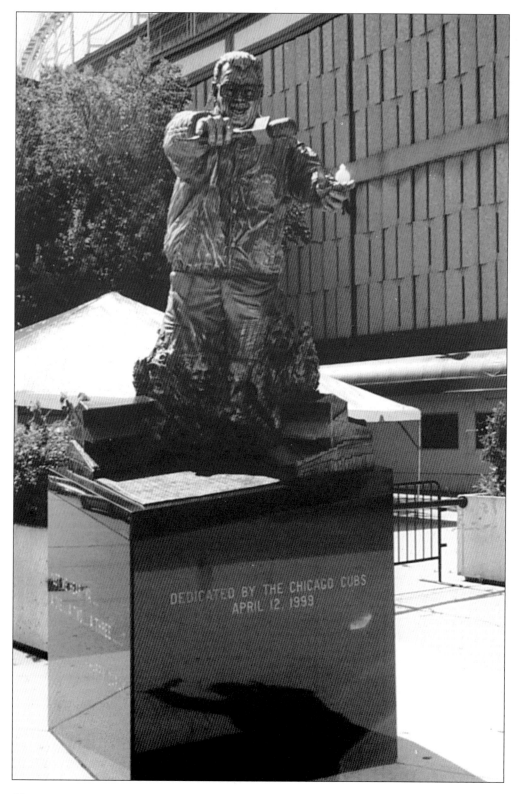

DEDICATED BY THE CHICAGO CUBS
APRIL 12, 1999

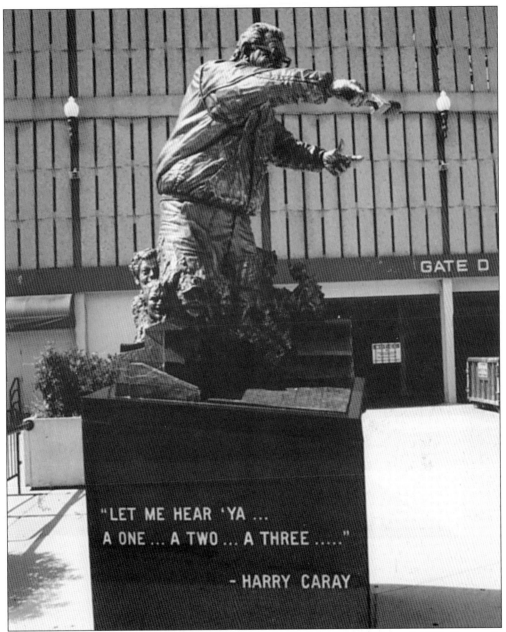

"LET ME HEAR 'YA ...
A ONE ... A TWO ... A THREE"

– HARRY CARAY

The late Harry Caray (1917–1998) was the voice of the Cubs from 1982 until 1997. Extremely popular among the citizens and Cubs' fans of Chicago, he was well-known for his exclamation of, *Holy Cow!* as well as for publicly leading crowds in a singing of *Take Me Out to the Ball Game* during the seventh-inning stretch. The 7-foot bronze tribute to Caray sits outside of Wrigley Field's Gate D near the corners of Addison and Sheffield. Co-sculpted by Omri Amrany and Lou Cella, the piece was made from 32 pieces of white bronze welded and sandblasted together and is placed on a 5-foot base of black granite. Weighing about 1,200 pounds, co-sculptor Cella stated that it took more than nine months to make. Wrigley Field is shown at the bottom, with the heads of adoring Cubs' fans rising up in front of Harry, whose arm is thrust forward as if to lead the fans in one last rendition of, *Take Me Out to the Ballgame* . . .(Photographs courtesy of author collection.)

Ticket Prices and Information

Box Seats *(Tax Included)*.. $1.65
Grandstand *(Tax Included)*.. 1.10
Bleachers *(Tax Included)*... .55

Children Under 12:

Box Seats *(Tax Included)*.. 1.10
Grandstand *(Tax Included)*.. .55
Bleachers *(Tax Included)*... .55

Reserved Box Seats may be purchased in advance: at any of the 100 Western Union offices in Chicago; by sending check or money order to Wrigley Field Ticket Office; or at Wrigley Field Box Offices A and B.

Rain Checks may be exchanged at the box office for any championship game of a later date. Rain checks are void after a game has progressed 4½ innings provided the Cubs are ahead. If Cubs are behind, however, rain checks are not void until the last half of the fifth inning has been played.

Ladies' Day: Send self-addressed stamped envelope to Ladies' Day Ticket Office, Wrigley Field. One ticket per envelope will be returned to the sender until the supply has been exhausted. A 10-cent government tax must be paid on each ticket at "tax" windows on day of game. Those wishing a box seat for Ladies' Day game should return ticket and 55 cents to Box Office, Wrigley Field, in advance, or present ticket and 55 cents at any Box Office on day of game. This does not include 10c Government Tax.

Special Group Seats: The management is prepared to make special provision for groups attending Wrigley Field in a body. Large or small blocks of seats may be reserved for social and fraternal bodies or salesmen's or employees' get-togethers. Reservations must be made in advance. Simply drop a line to Wrigley Field Ticket office or call us at BUCkingham 5050 to let us know that you're planing to bring a party to Wrigley Field for a special "day" and we'll be happy to arrange all details for you.

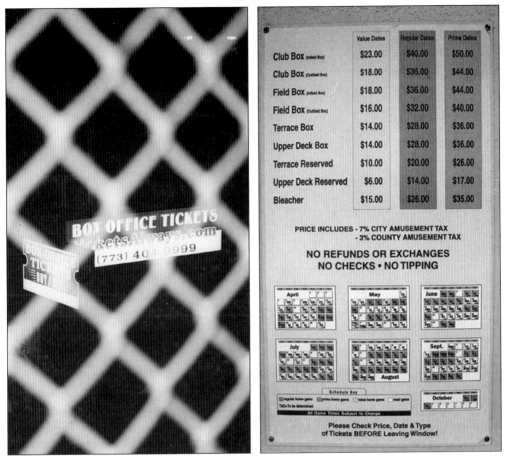

	Value Dates	Regular Dates	Prime Dates
Club Box (Infield Box)	$23.00	$40.00	$50.00
Club Box (Outfield Box)	$18.00	$36.00	$44.00
Field Box (Infield Box)	$18.00	$36.00	$44.00
Field Box (Outfield Box)	$16.00	$32.00	$40.00
Terrace Box	$14.00	$28.00	$36.00
Upper Deck Box	$14.00	$28.00	$36.00
Terrace Reserved	$10.00	$20.00	$26.00
Upper Deck Reserved	$6.00	$14.00	$17.00
Bleacher	$15.00	$26.00	$35.00

PRICE INCLUDES - 7% CITY AMUSEMENT TAX
- 3% COUNTY AMUSEMENT TAX

NO REFUNDS OR EXCHANGES
NO CHECKS • NO TIPPING

Please Check Price, Date & Type
of Tickets BEFORE Leaving Window!

Note the difference in ticket prices from a game in 1941 (opposite) and today (above right). Equally notable is the variety in seating choices today. Fans desperate for tickets may opt for alternative means, as evidenced in the photograph above, left. (Photographs courtesy of author collection.)

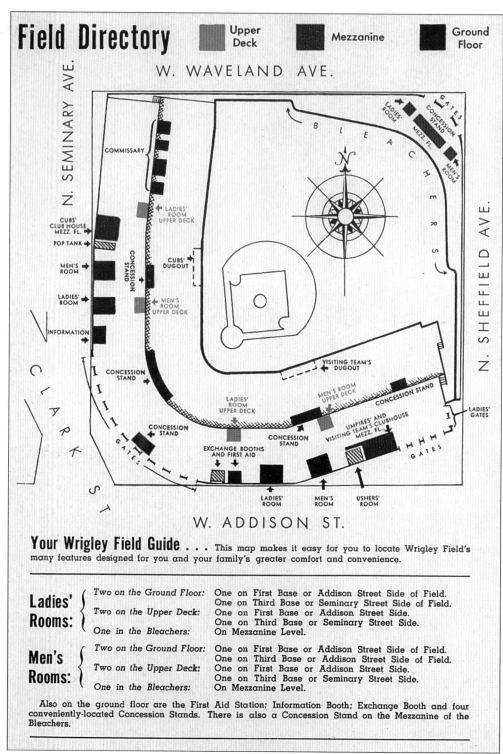

Field Directory

Upper Deck Mezzanine Ground Floor

W. WAVELAND AVE.

N. SEMINARY AVE.

N. SHEFFIELD AVE.

COMMISSARY

CUBS' CLUB HOUSE MEZZ. FL.
POP TANK
MEN'S ROOM
LADIES' ROOM
INFORMATION
CONCESSION STAND
CONCESSION STAND

LADIES' ROOM UPPER DECK
CUBS' DUGOUT
MEN'S ROOM UPPER DECK

B L E A C H E R S

LADIES' ROOM
CONCESSION STAND
MEZZ. FL.
MEN'S ROOM

GATES

N

VISITING TEAM'S DUGOUT

MEN'S ROOM UPPER DECK
CONCESSION STAND

LADIES' GATES

LADIES' ROOM UPPER DECK
CONCESSION STAND
UMPIRES' AND VISITING TEAM'S CLUBHOUSE MEZZ. FL.

C L A R K S T

GATES

EXCHANGE BOOTHS AND FIRST AID

LADIES' ROOM MEN'S ROOM USHERS' ROOM

H H H GATES

W. ADDISON ST.

Your Wrigley Field Guide . . . This map makes it easy for you to locate Wrigley Field's many features designed for you and your family's greater comfort and convenience.

Ladies' Rooms:	Two on the Ground Floor:	One on First Base or Addison Street Side of Field. One on Third Base or Seminary Street Side of Field.
	Two on the Upper Deck:	One on First Base or Addison Street Side. One on Third Base or Seminary Street Side.
	One in the Bleachers:	On Mezzanine Level.
Men's Rooms:	Two on the Ground Floor:	One on First Base or Addison Street Side of Field. One on Third Base or Addison Street Side of Field.
	Two on the Upper Deck:	One on First Base or Addison Street Side. One on Third Base or Seminary Street Side.
	One in the Bleachers:	On Mezzanine Level.

Also on the ground floor are the First Aid Station; Information Booth; Exchange Booth and four conveniently-located Concession Stands. There is also a Concession Stand on the Mezzanine of the Bleachers.

A Field Directory from a 1940s program details the interior features of a pre-World War II Wrigley Field.

The Cubs' dressing room offers the players changing quarters, a kitchen at the far end of the room, and tables and stools at which to eat meals. Fan mail is typically stacked on the chair directly in front of each player's dressing closet. (Photographs courtesy of author collection.)

Chicago Cubs News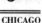

VOL. 20, NO. 3 WRIGHT FIELD, JULY 21, 1955 CHICAGO

TV AUDIO SECTION FOR FANS

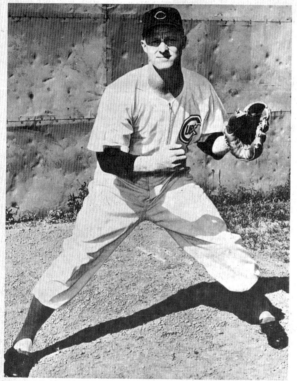

COMEBACK KID!... Warren Hacker, fireballing right hander, is one of the principal factors in the Cubs' improved showing this season. Looking like he did in 1952, when he won 15 games, Hacker has a good chance to top that figure this year.

Now You Can Watch Game and Listen to Telecast

As a service to fans who like to enjoy seeing a ball game plus all that the TV announcer has to offer, a small section of the left field grandstand at Wrigley Field has been set aside as the "TV Audio Section."

This section gives an excellent wide angle view of the field and game, and is equipped with modulated loud speakers which convey the voice of WGN-TV's telecast exactly as it is broadcast. In effect, the people in this section will be members of a studio audience, seeing the actual performance as they listen to what goes on the air.

Although the Cub management tries to keep the fans informed on developments of the ball game through the public-address system, it is not possible to give as much information as is available to those listening to and watching broadcasts and telecasts.

Therefore, the Cubs decided to install this "TV Audio Section," making the detailed information about the game that goes on the air available to those who wish it.

The TV voice is that of Jack Brickhouse, WGN-TV's renowned sports authority, who has over 15 years' experience as a major league announcer and has televised more major sports events than any other announcer in the country.

If you decide to try the "TV Audio Section" when you come to Wrigley Field, any one of the Andy Frain ushers will be glad to direct you to it. There is no extra charge for the "TV Audio Section," and the commentary on the game is limited to this section.

Four double headers and this year's only Sunday game with Brooklyn feature this coming home stand. Consult the schedule on page 4. To be sure of getting to see some of these exciting games, order your box seat tickets now, using the order blank-envelope sent with this CUBS NEWS.

Order Box Seat Tickets Now for Rest of Season!

Use the Convenient Order Blank-Envelope Sent YOU with this Issue

No Postage Required for Mailing

A Chicago Cubs News from July 21, 1955, details the splendor of a new TV audio section for fans.

The headline on the opposite page from 1955 seems rather novel when one considers the technology available to us today. The broadcasting booth (above and right) is strategically located above the fans for greater accuracy in analyzing games. Notice the illustration positioned on one of the upper windows that pays homage to the late Harry Caray, one of the Cubs' most memorable announcers. (Photographs courtesy of author collection.)

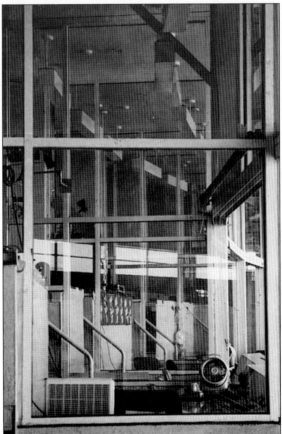

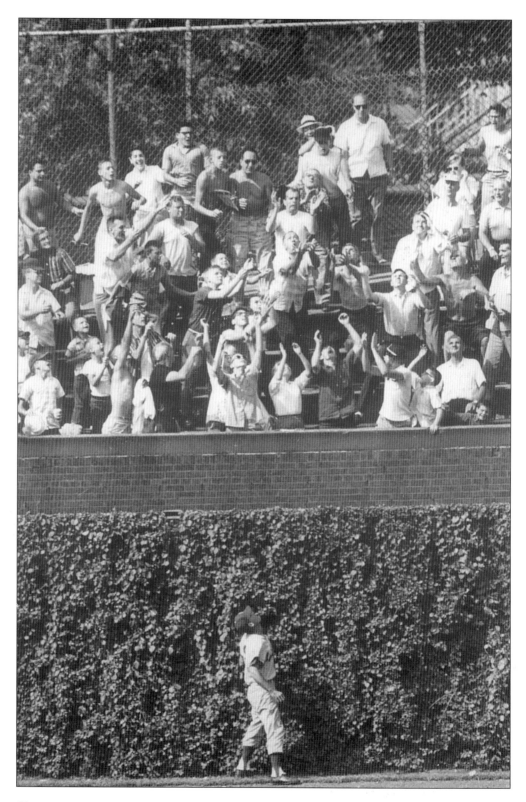

The bleacher seats have long been a place for maverick Cubs' fans hoping to just catch a fly ball or enjoy a few beers with friends. (Photographs courtesy of author collection.)

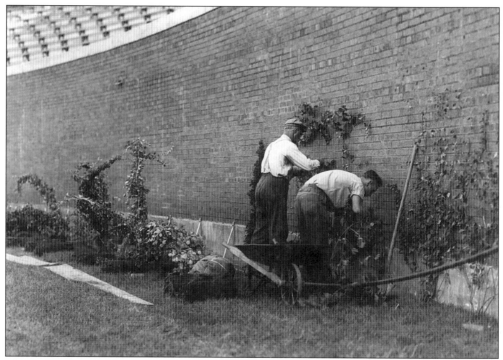

The original vines were purchased and planted by Bill Veeck in September of 1937. The bleacher wall is 11.5 feet high, with bittersweet running from the top of the wall to the bottom and ivy planted at the base of the wall. (Photograph courtesy of George Brace collection.)

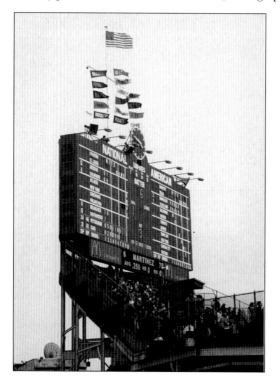

The scoreboard, also Veeck's brainchild, was constructed in 1937 when the outfield area was renovated to provide improved and expanded seating. Despite a homerun hit onto Sheffield Avenue (right-center) by Bill Nicholson in 1948 and a hit by Roberto Clemente onto Waveland Avenue (left-center) in 1959, the centerfield scoreboard has never been hit by a batted ball. The score-by-innings and the pitchers' numbers are changed manually. (Photograph courtesy of author collection.)

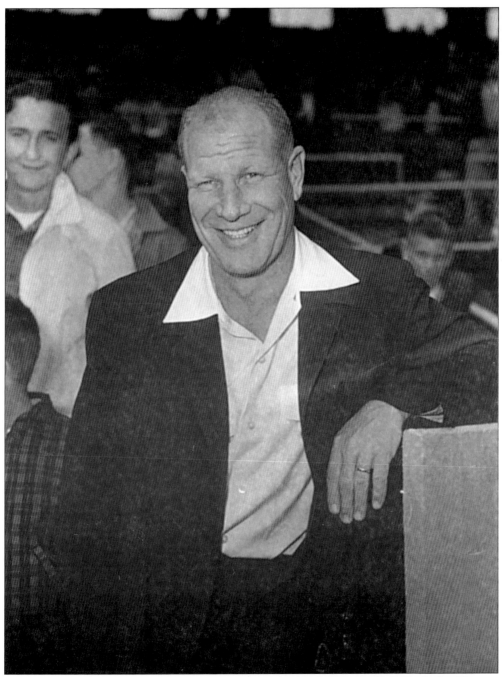

The late Bill Veeck (1914–1986) was a pioneer in the baseball industry for both the Chicago Cubs and the Chicago White Sox, among other teams. His contributions to baseball—including a midget ball player, fireworks, exploding scoreboards, and player names on the backs of uniforms—are remembered to this day, in addition to the ivy and scoreboard at Wrigley. Including his photograph in this book reminds me of the last lines taken from his 1962 book, *Veeck as in Wreck*, "Look for me under the arc lights, boys. I'll be back." (Photograph courtesy of George Brace collection.)

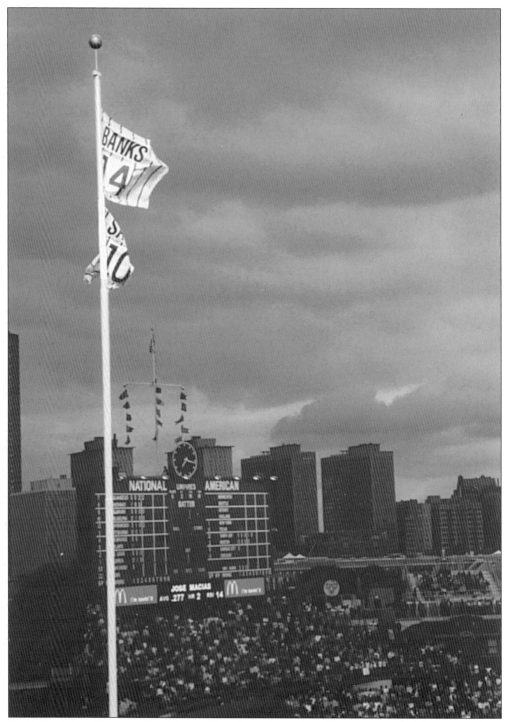

Ernie Banks' uniform number 14 and Ron Santo's number 10 were retired and imprinted on flags which fly from the left field foul pole. Billy Williams' number 26 (not pictured) was also retired and flies from the right field foul pole—an area in which it was difficult to obtain tickets this last season. (Photographs courtesy of author collection.)

There really are tickets sold for "standing room only," shown here by these fans making creative use of the handrails. Only a true Cubs' fan would stand for an entire nine innings of baseball. (Photograph courtesy of author collection.)

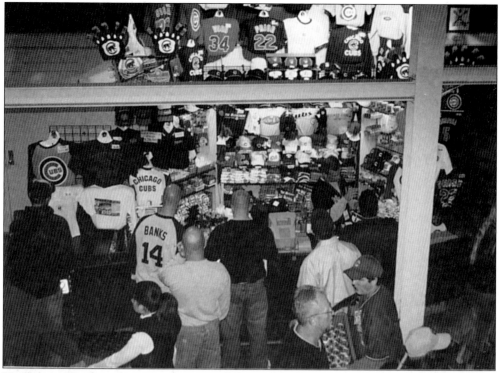

Vending at Wrigley takes many forms, including sales of souvenir attire (pictured above) or a hot dog prepared with a spray of mustard. (Photographs courtesy of author collection.)

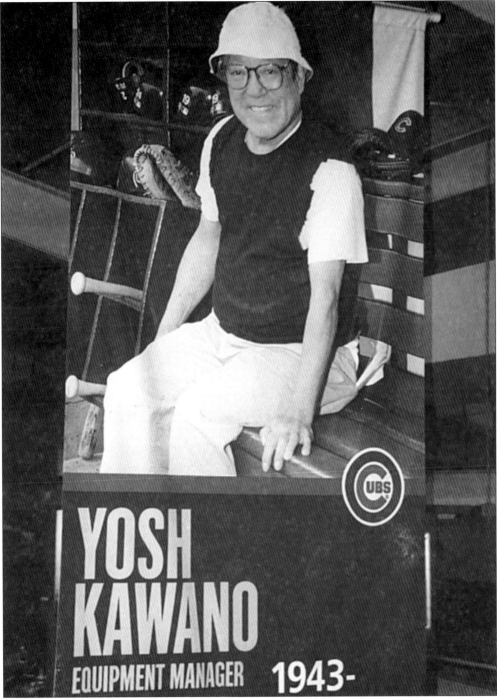

A banner honoring the legendary Yosh Kawano hangs in Wrigley for every Cubs' fan to see. Kawano, as stated on the banner, has worked for the Chicago Cubs as the Equipment Manager for a remarkable 62 years! When he was congratulated in 1984 for the Cubs near-miracle season, Kawano replied: "I didn't get blamed when the Cubs lost. Why should I take credit for winning?" (Photograph courtesy of author collection.)

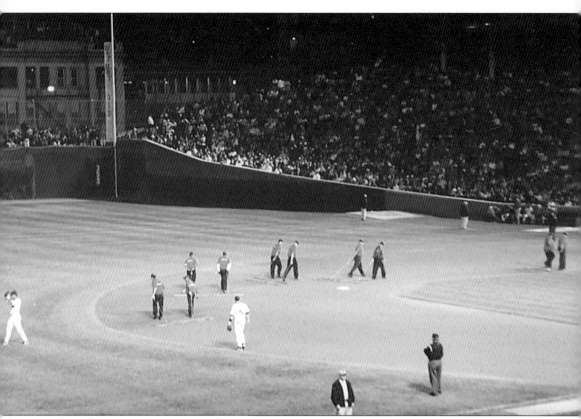

Members of the grounds crew sweep the field during a commercial for one of the televised games. (Photograph courtesy of author collection.)

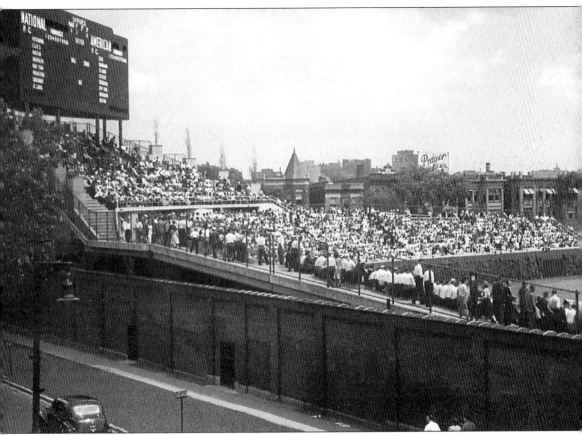

This photograph was taken from across Waveland Avenue on May 28, 1939, as a Sunday crowd filled Wrigley on Memorial Day weekend to watch Dizzy Dean beat the Pittsburgh Pirates after the two teams had staged a death struggle for the pennant in the fall of 1938. Note the differences in this image from the view we have today: bleacher patrons are attired in their Sunday best, no clock on the scoreboard, and Chinese Elm trees along the steps in the top bleacher section (the trees were later ruined by prevailing winds off Lake Michigan). Also, the only visible advertising in sight is the sign for Atlas Prager Beer. (Photograph courtesy of author collection.)

Two attendees to an evening game sneak out early, then try to catch an updated score. (Photograph courtesy of author collection.)

Why drive when you can ride comfortably in a modern rickshaw? This dad and his two children opt for more scenic transportation out of the ballpark after enjoying the evening's game. (Photograph courtesy of author collection.)

FIVE

Dreamers, Vendors, and Fans

Our audiences are composed of the best class of people in Chicago, and no theater, church, or place of amusement contains a finer class of people than can be found in our grandstands.
Albert G. Spaulding, White Stockings Owner, 1883

Cubs' fans have been fired from jobs, taken jobs to be near the Cubs, and called in sick to their jobs every year on Opening Day as the price of loyalty for cheering the team. This devoted lot of humanity bleeds blue and truly believes that every year is a season of hope. In a 2003 SportsIllustrated.com article by columnist David Vecsey, Chip Caray (grandson to Harry) offered his take on the fans who offer their undying devotion to the team: "I think Cub fans are optimists in the sense that many of them truly believe every year that this is going to be the year. . . . Cub fans have emotionally copyrighted the phrase 'Wait 'till Next Year.'"

Alex Peterson and his father, David Peterson, enjoy a view from the dugout during a Cubs Care tour in the spring of 2004. (Photograph courtesy of David Peterson.)

Even if all you know about baseball is that the home team bats last, you know about Wrigley Field - the ballplayers who romped there, the famous announcers, the ivy-covered walls. But *beyond the ivy*, there's another side - the games surrounding the game.

"Wrigley Field: Beyond the Ivy" takes you from the rooftops to the bleachers and back down to the streets where odd and obsessive characters turn a day and night at Wrigley Field into a truly unique experience.

The acclaimed team that created "The Wrecking of Old Comiskey Park" now brings you the secret dream life of Wrigley Field. Narrated by **William Petersen** (star of TV's "CSI: Crime Scene Investigation"), with a musical score by jazz great Bradley Williams (of radio's long running "Words and Music"), "Beyond the Ivy" explores one neighborhood of baseball that you haven't visited before.

Approximate running time 100 minutes.

Narrated by William Petersen • Written by Bob Chicoine, David Levenson, Jim Hausfeld, Jimmy Mack • Original music by Bradley Williams • Edited by Jim Hausfeld • Directed by David Levenson

Bougainville Productions

© 2001 Bougainville Productions.

www.wrigleyfieldvideo.com

8 20218 48233

Narrated by William Petersen

Beyond the Ivy is a must-see documentary for every Chicagoan, every Cubs' fan, and every student of baseball. Narrated by William Petersen, a native of the Chicago area, the 100-minute documentary combines a look at some quirky characters along with some beautiful views of the cityscape surrounding Clark and Addison. (Courtesy of David Levenson.)

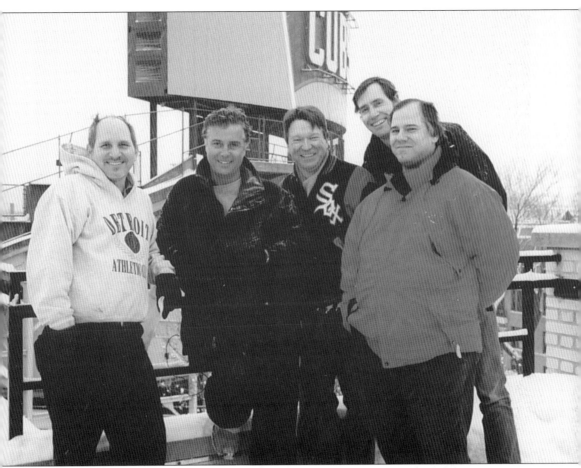

The creative forces behind *Beyond the Ivy* pose with actor and narrator William Petersen on a neighboring rooftop. (Photograph courtesy of David Levenson and Lori Hausfeld.)

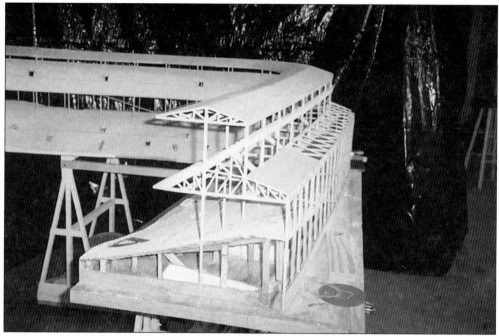

Steve Wolf, a devoted Cubs dreamer who is also a White Sox fan, left a career in the printing business to follow his talent and dream of building major league models.

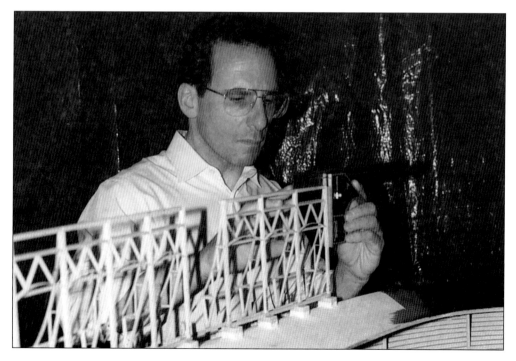

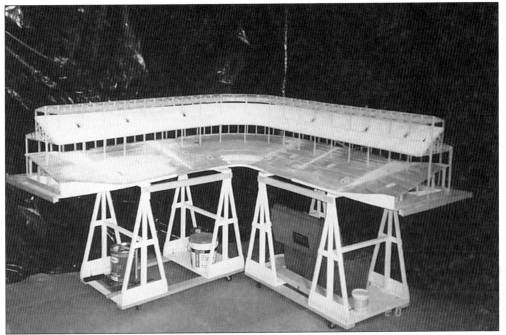

The model of Wrigley Field pictured here, which later sold for an undisclosed sum, took Steve almost three years to complete. "Ball parks are the most overlooked American piece of architectural history we have," stated Wolf. (Photographs courtesy of Steve Wolf.)

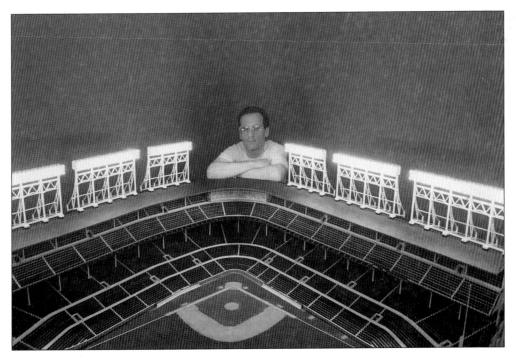

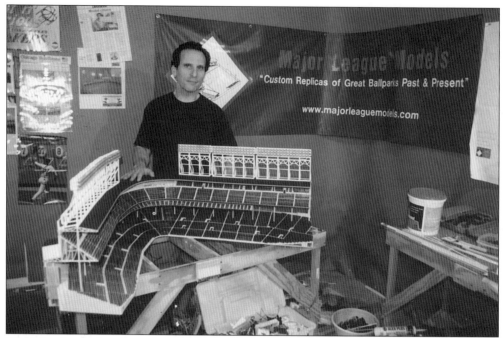

Wolf was featured in *Beyond the Ivy* and now makes a full-time career running his company, Major League Models. Pictured above is Wolf in his studio with a completed model. Pictured below is Wolf's Wrigley Field model, which is now on display at Murphy's Bleachers in Chicago. (Photographs courtesy of Steve Wolf.)

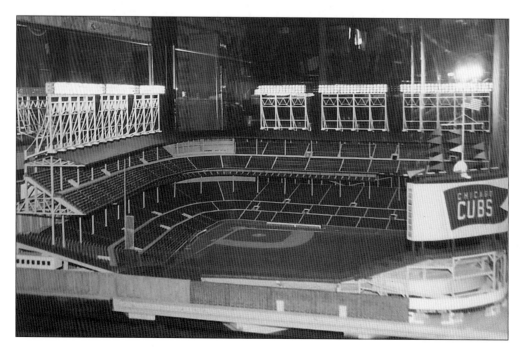

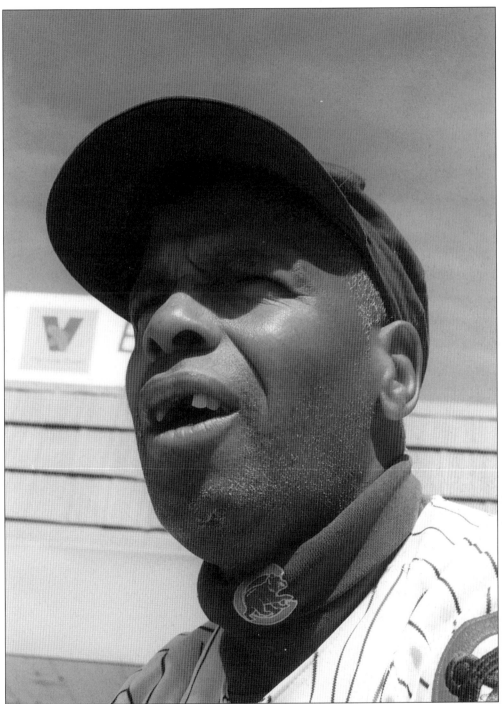
Ronnie "Woo Woo" Wickers, the Cubs' unofficial troubadour, became an inspired Cubs' fan after seeing Jackie Robinson play at Wrigley Field. As a dedicated Cubs' fan for the past five decades, Ronnie has inspired such players as Ernie Banks, Roberto Clemente, Hank Aaron, and Willie Mays. Should you ever see Ronnie at a Cubs' game, consider yourself blessed. (Photograph courtesy of David Levenson.)

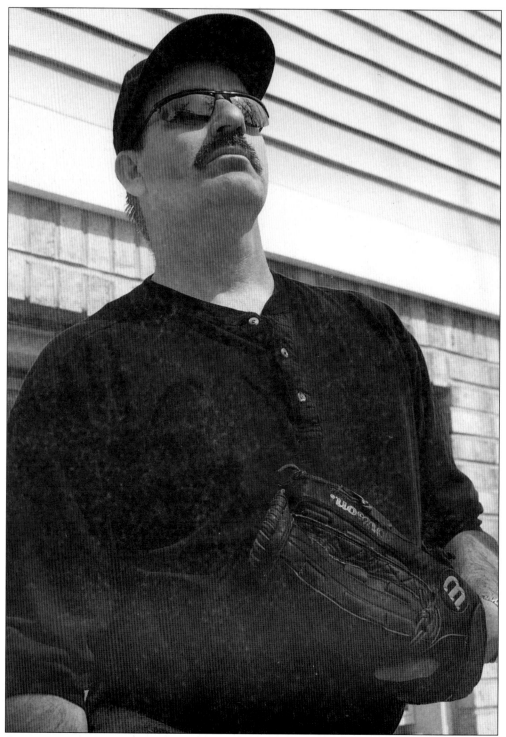

Gary "Moe" Mullins, one of many "Ballhawks" who congregate on Waveland Avenue outside of Wrigley Field waiting to catch homerun balls, has caught well over 3,000 balls, including Sammy Sosa's historic homerun No. 62. (Photograph courtesy of David Levenson.)

Ballhawks assume their positions on Waveland Avenue outside of Wrigley Field. (Photograph courtesy of author collection.)

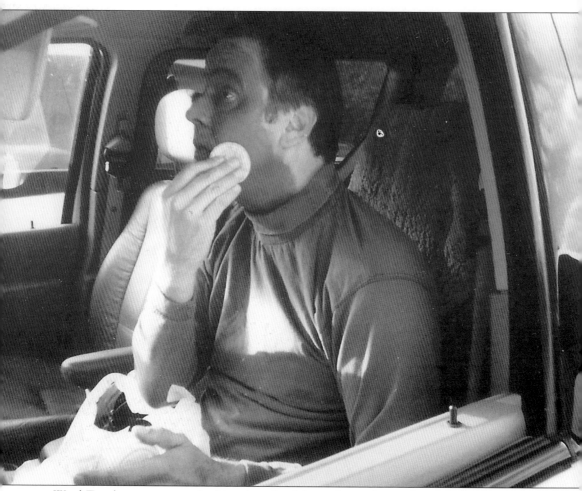

Ward Tannhauser prepares for his role as Ivy Man as he applies makeup inside of his vehicle before making a much-awaited appearance outside of the ball park (opposite). The Crystal Lake resident travels close to 100 miles round trip to see his beloved Cubs. (Photographs courtesy of Ward Tannhauser.)

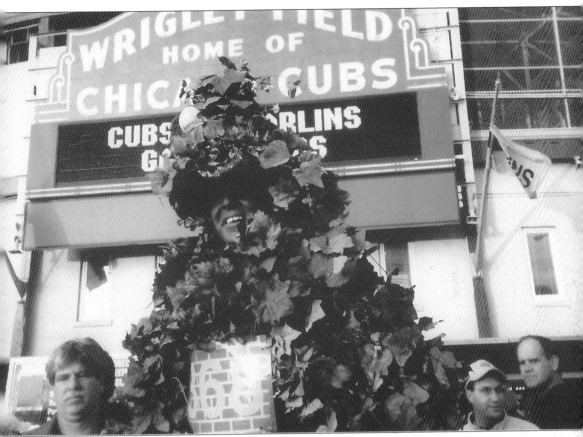

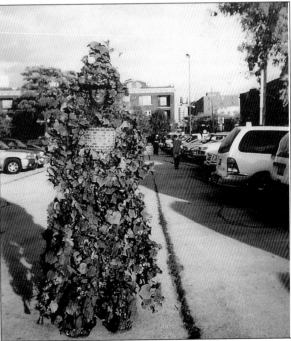

ADD TO YOUR FUN...Take Advantage of Wrigley Field's Modern Restaurants . . . Convenient Vendors

Appetizing treats and refreshing drinks are offered you by Wrigley Field's sanitary restaurants and uniformed vendors.

Come out early — lunch leisurely. Then you're all set to watch batting and infield practice. And here's a hint:

Wrigley Field's hot roast beef and baked ham sandwiches are famous for their goodness.

During the game, vendors are always on hand to serve you quickly at your seat, so that you miss none of the thrilling action.

THESE ITEMS SOLD BY BOTH RESTAURANTS AND VENDORS:

FOOD AND BEVERAGES:

Tasty Red Hots (Oscar Mayer's)—
 Juicy Hamburgers10c
Ice Cream: Borden's "Frosticks"
 and Cup Sundaes 5c
Coffee10c
Beer (Pabst)—In Cans or Bottles
 —20c—On Draught10c
Coca-Cola—Manhattan Orange and
Root Beer—Orange Crush.........10c
Ginger Ale and Sparkling Water...15c

SUNDRIES:

Pencils—5c; Sun Glasses—25c; Post
 Cards—3 for 5c
Autographed Pictures 25c
Official Cubs Record Book.........10c

CONFECTIONS AND CHEWING GUM:

Bit O'Honey—Old Nick—Baby Ruth
 —Milky Way and other popular
 brands of candy................ 5c

Wrigley's Spearmint, Doublemint
 and "Juicy Fruit" Chewing Gum.. 5c
Beeman's, Beechnut and other popular brands of Chewing Gum...... 5c

CIGARETTES AND CIGARS:

All popular brands of cigarettes....15c
Ben Bey Cigars................... 5c
Ben Bey, Dutch Master, Webster and
 other popular brands.....10c & 15c

THESE ITEMS SOLD ONLY BY RESTAURANTS:

Roast Beef—Baked Ham
 Sandwiches20c
Egg—Cheese Sandwiches15c

Pie—10c & 15c; Doughnuts........ 5c
Borden's Milk, Chocolate Milk and
 Buttermilk10c

THESE ITEMS SOLD ONLY BY VENDORS:

Scorecards—Popcorn—Peanuts10c
Sporting News—Cushions (rented)..10c

Lemonade20c
Miniature Bats, Souvenir Rings.....25c

A menu taken from a 1941 baseball program details Wrigley Field's culinary offerings. Imagine—a draught beer for 20 cents! (Courtesy of author collection.)

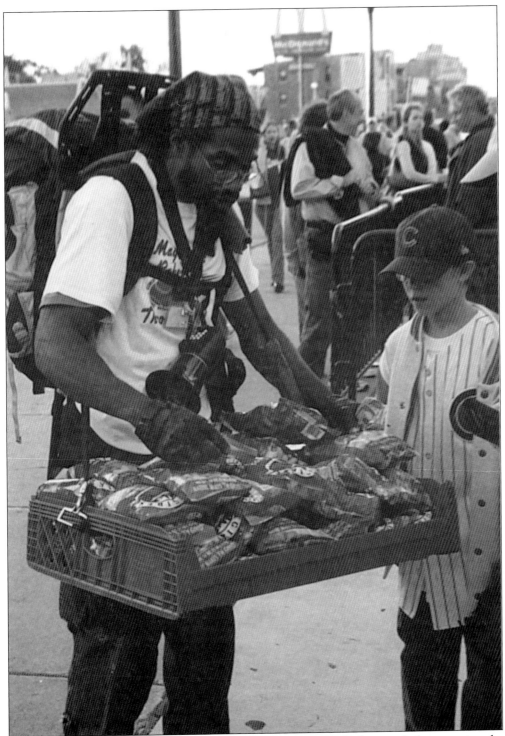

Many outside vendors stand ready to sell various snacks and refreshments before entering the ballpark. This peanut vendor is suitably prepared for a long afternoon with his backpack full of supplies and a loudspeaker to advertise his product. (Photograph courtesy of author collection.)

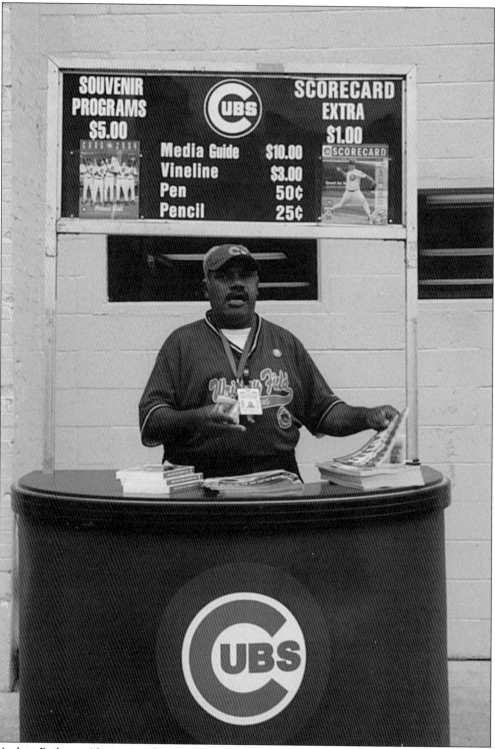

Arthur Bailey, a 10-year employee of Aramark, sells programs and scorecards outside of the ballpark. (Photograph courtesy of author collection.)

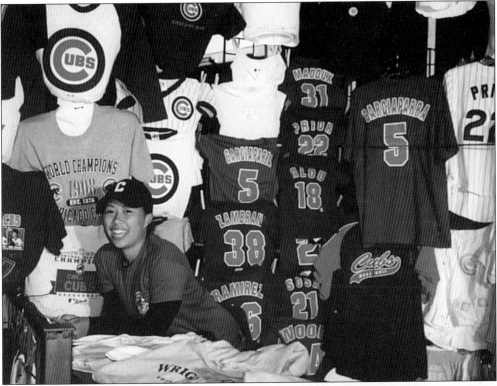

Christine Pundavela (pictured above) and Matthew Markunas (pictured right) work the areas outside of Wrigley Field selling shirts and sweatshirts to fans who want a souvenir of their trip to Wrigley Field.

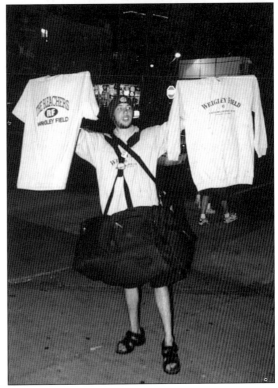

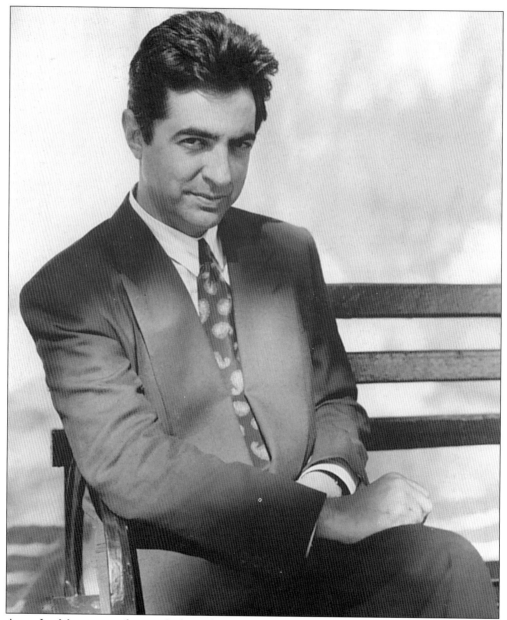

Actor Joe Mantegna—famous for his roles in *House of Games*, *The Godfather—Part III*, and *The Rat Pack*, to name only a few—shared his inspiration for the Cubs and Wrigley Field when he conceived the play, *Bleacher Bums*. The genesis for *Bleacher Bums*, according to Mantegna:

> It basically came from all my years sitting in Wrigley being mystified as to what force brought such a divergent group of people together, day after day, year after year, to follow a team that never lived up to their expectations. I became fascinated by the concept of what it was to be a "fan", and that by being one caused a person to instantly become a member of a select club that was not defined by race, religion, economic status, sex, or any other criteria except that all members shared the adulation for the same team, and in this case, arguably the hardest team of all to devote oneself to.

(Photograph courtesy of Joe Mantegna.)

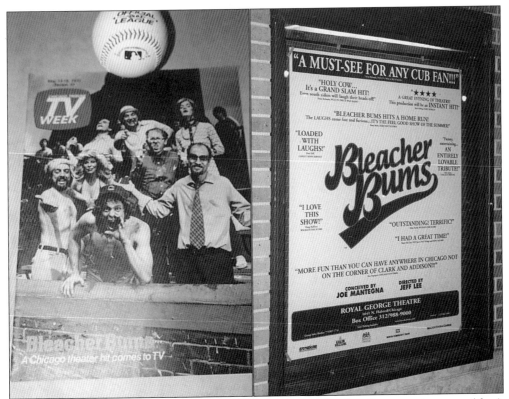

An early TV Guide from 1979 features the then-cast of Bleacher Bums on its cover (that's Mantegna on the left with a beard); 25 years later, a marquis at a local Chicago theater advertises the play when it returned to Chicago in 2004. (Photographs courtesy of author collection.)

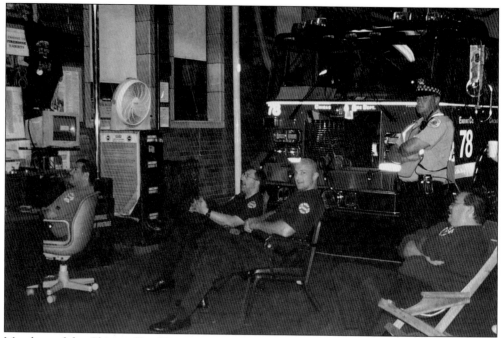

Members of the Chicago Fire Department and an officer from the Chicago Police Department take a break to catch the Cubs' game on television. This firehouse is situated directly across the street from Wrigley and in my opinion, must be one of the best places in Chicago in which to work. (Photograph courtesy of author collection.)

Cubs' fans Tyler Jason and Ryan Jeffery take a break from their college studies to enjoy a night game at Wrigley. (Photograph courtesy of author collection.)

Jenni Maschmann, Cheryl Bowers, Bruce Bowers, and Bruce Bowers, Sr. enjoy a summer afternoon inside the Friendly Confines. Thanks for the extra Cubs plug, Jenni. . . . (Photograph courtesy of Bowers family.)

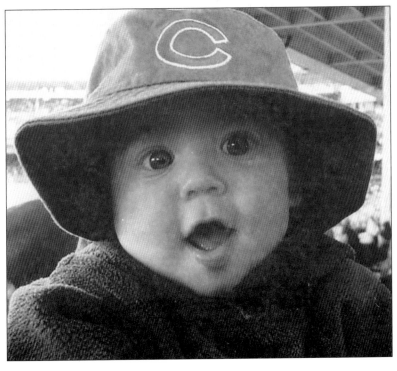

A smiling Luke Gertsmeier sports the latest fashion for infant Cub fans: a Chicago Cubs bucket hat that seems to fit perfectly. Go Cubs, Luke! (Photograph courtesy of April Armer.)

City residents April Armer, Gayle Mountcastle, and Michelle Tuft sneak away from their "standing room" only spot to relax with a more comfortable view of the game. (Photograph courtesy of April Armer.)

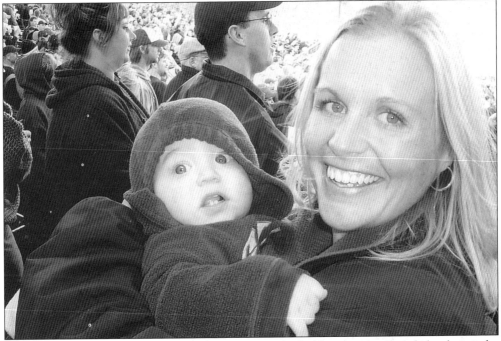

Cubs' fan Joan Bowers looks absolutely radiant as she holds someone else's baby during the seventh-inning stretch. (Photograph courtesy of author collection.)

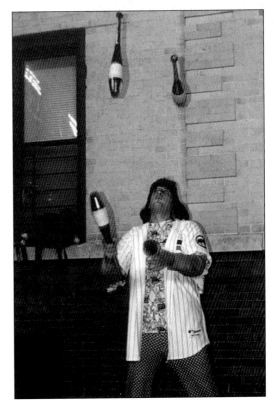

Sam Dardick celebrates 1970s night outside of Wrigley Field by demonstrating his juggling skills. (Photograph courtesy of author collection.)

Cubs Care is a charitable organization that contributes monetary grants to organizations that help children with special needs, victims of domestic violence, and youth sports programs. To date, Cubs Care has granted in excess of $7 million in support of organizations throughout the Chicago community. Anthony Reinhardt, a devoted Cubs' fan, was a dedicated supporter of Cubs Care and highly active in the organization. (Photograph courtesy of Reinhardt family.)

Six

Controversies

Aw, everybody knows that game, the day I hit the homer off ole Charlie Root there in Wrigley Field, the day October first, the third game of that thirty-two World Series. But right now I want to settle all arguments. I didn't exactly point to any spot, like the flagpole. Anyway, I didn't mean to, I just sorta waved at the whole fence, but that was foolish enough. All I wanted to do was give that thing a ride...outta the park...anywhere...
Babe Ruth on the famous "called shot"

Wrigley Field's first controversy wasn't a goat, a cat, lights, or nets.

Wrigley Field's first controversy stemmed from Charlie Weeghman looking north to build a ballpark in a neighborhood that lacked the atmosphere for which it is so well known today. When Wrigley Field was in its infancy as Weeghman Park, a coal yard sat directly across the street. The surrounding area—lined with rows of frame homes, warehouses, and a railroad yard—was not as fashionable and popular as the spacious Comiskey Park to the south. Still, Weeghman's vision paid off and the years that followed gave birth to its own set of unique controversies that have riddled the Cubs with love, loyalty, criticism, and loathing in the nine decades that have followed. Put aside the rumors and innuendos associated with Babe Ruth's called shot, the Green Light letter from President Roosevelt (which may be new history for younger readers . . .), the Sianis goat curse, the black cat of '69, and the public tirade in 2003 against a nameless Cubs' fan whose actions should have been absolved by baseball rule 3.16, and consider the headlines from the 2004 season: *Cubs order net to catch falling Wrigley chunks* (Chicago Sun-Times), *City threatens to shut down games at Wrigley* (AP), *Man killed near Wrigley after attending game* (ESPN.com), *Sosa likely to file grievance over $87,400 fine* (AP), *End of broadcast era: Stone resigns* (Chicago Sun-Times).

As the edifice continues to age and public patience with the team continues to thin, the greatest controversy faced by Wrigley Field in the 21st Century may be whether to move.

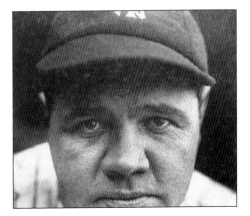

Babe Ruth's famous "called shot" has been the subject of speculation since it occurred on October 1, 1932, in Game Three of the World Series. The legend states that Babe had been jeered by players and Cubs' fans throughout the game. He gestured towards the center field bleachers before hitting a homerun on the next pitch. Had he predicted the hit? Or was he pointing at unruly fans in a gesture of defiance? Cubs pitcher Charlie Root denied the prediction had taken place, while Ruth claimed it had, offering several different versions of the story. (Photograph courtesy of author collection.)

THE WHITE HOUSE
WASHINGTON

January 15, 1942.

My dear Judge:-

Thank you for yours of January fourteenth. As you will, of course, realize the final decision about the baseball season must rest with you and the Baseball Club owners -- so what I am going to say is solely a personal and not an official point of view.

I honestly feel that it would be best for the country to keep baseball going. There will be fewer people unemployed and everybody will work longer hours and harder than ever before.

And that means that they ought to have a chance for recreation and for taking their minds off their work even more than before.

Baseball provides a recreation which does not last over two hours or two hours and a half, and which can be got for very little cost. And, incidentally, I hope that night games can be extended because it gives an opportunity to the day shift to see a game occasionally.

As to the players themselves, I know you agree with me that individual players who are of active military or naval age should go, without question, into the services. Even if the actual quality of the teams is lowered by the greater use of older players, this will not dampen the popularity of the sport. Of course, if any individual has some particular aptitude in a trade or profession, he ought to serve the Government. That, however, is a matter which I know you can handle with complete justice.

Here is another way of looking at it -- if 300 teams use 5,000 or 6,000 players, these players are a definite recreational asset to at least 20,000,000 of their fellow citizens -- and that in my judgment is thoroughly worthwhile.

With every best wish,

Very sincerely yours,

Franklin D. Roosevelt

Hon. Kenesaw M. Landis,
333 North Michigan Avenue,
Chicago,
Illinois.

President Roosevelt's historic Green Light Letter to Judge Kenesaw Mountain Landis, the Commissioner of Baseball, gave the "green light" to continued baseball games during the World War II years. Judge Landis (pictured opposite page) helped restore public confidence in baseball following the "Black Sox" scandal of 1919, in which he banned for life eight White Sox players who were accused of throwing the 1919 World Series. (Photographs courtesy of author collection.)

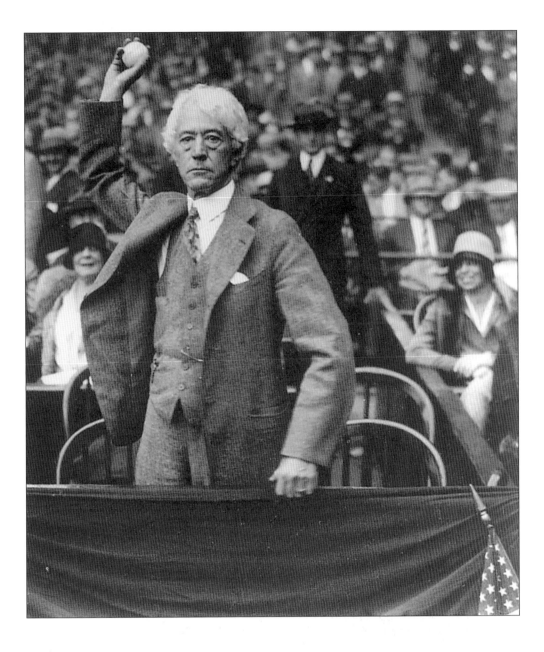

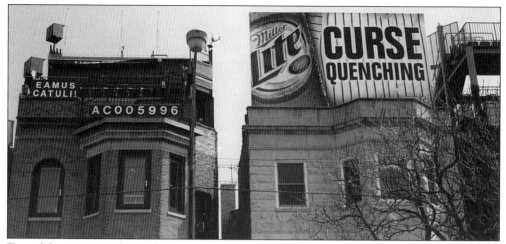

Two of the more popular rooftop signs outside of Wrigley stand directly next to each other. The first building is the headquarters for the Lakeview Baseball Club at 3633 North Sheffield. The Latin "Eamus Catuli" is loosely translated as "Let's Go Cubs"; the "AC" stands for "anno catuli"and measures the year in Cubs time. The first two digits mark the number of years since the Cubs won their division, the next two digits indicate the number of years since the Cubs won a National League pennant, and the final two digits indicate the number of years since the Cubs won the World Series. The Miller Lite billboard housed on the building next door always incorporates catchy advertising related to the Cubs and sometimes, their opponents. (Photograph courtesy of author collection.)

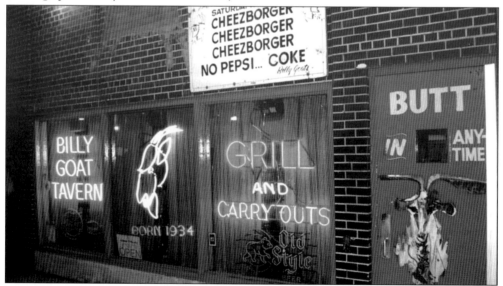

The Billy Goat Tavern, located at 430 North Lower Michigan Avenue, is the home of the "Billy Goat Curse" that is said to have plagued the Cubs. The story goes like this: Sam Sianis, the original owner of the Billy Goat Tavern, took his goat "Murphy" to the 1945 World Series for which he held two tickets. P.K. Wrigley reportedly denied the goat entrance into the park. When Sianis asked why they wouldn't allow the goat entrance, he was told, "Because the goat smells." Sianis left and allegedly said, "Cubs, they not gonna win anymore." The Cubs then lost to Detroit and Sianis sent a telegram to P.K. Wrigley that read: "Who smells now?" And thus, the famous curse began. (Photograph courtesy of author collection.)

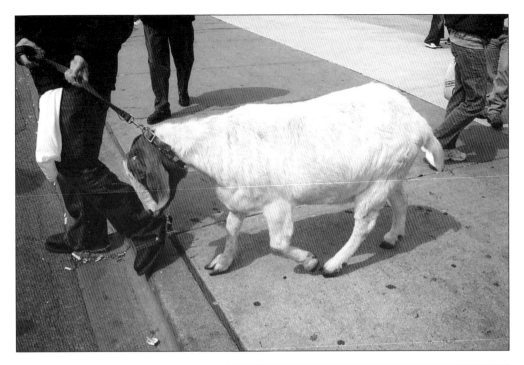

Two goats graced Wrigley Field on Opening Day in 2004: a real goat (unrelated to the Sianis legend) and a taller goat that shook my hand after I snapped this photo. Maybe I should start playing professional baseball. . . . (Photographs courtesy of author collection.)

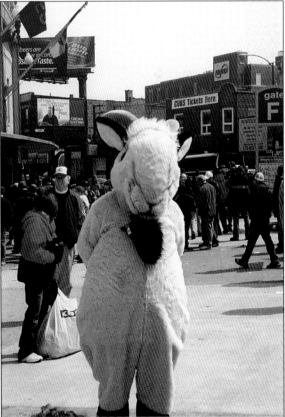

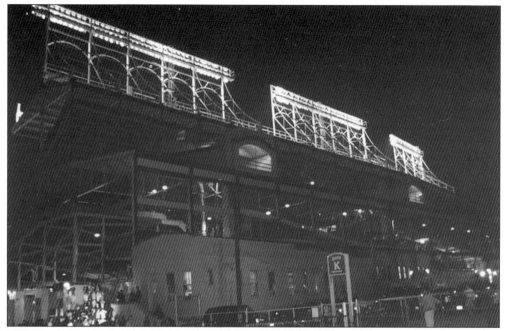

P.K. Wrigley had lights ready to be installed at Wrigley Field in the winter of 1941, but then donated the steel for the light towers to the war effort. After the war had ended, Wrigley resisted installing lights, dismissing evening baseball as "a passing fancy." Forty-seven years later, lights were installed at Wrigley Field under the ownership of the Tribune Company, although one neighborhood activist group opposed the lights, believing it would add to the noise pollution and excessive evening traffic. The first night game took place on August 8, 1988 (8-8-88) against Philadelphia; it was rained out after only 3 1/2 innings. The first official full night game took place the next evening, on August 9, when the Cubs defeated the New York Mets 6-4.

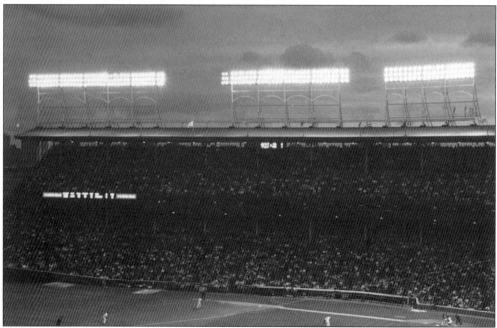

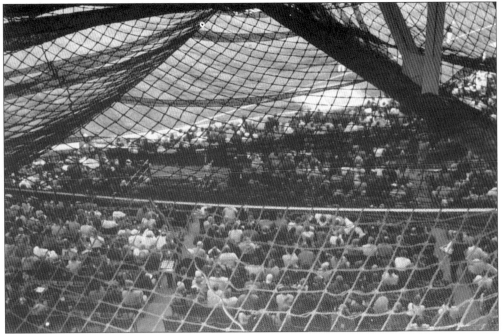

Loose chunks of concrete fell from Wrigley Field's upper deck in June and July of the 2004 season. Although the first incident occurred on June 9, the controversy hit the headlines in mid-July after a chunk fell on the third base side and just missed a man attending the game with his 5-year-old son. Mayor Daley ordered an immediate hands-on inspection of Wrigley's structure, threatening to shut down the stadium if necessary. As a temporary measure, Wrigley officials installed netting under the areas in question and took various other necessary steps, with inspections by structural engineers. Despite the war of words that took place in the newspaper headlines between the mayor and ballpark officials, "Wrigley falling" did little to deter a noticeable decrease in game attendance, as these photos illustrate. (Photographs courtesy of author collection.)

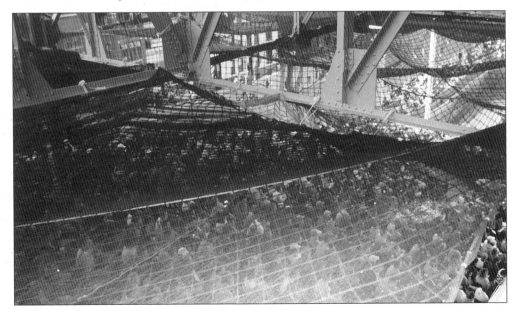

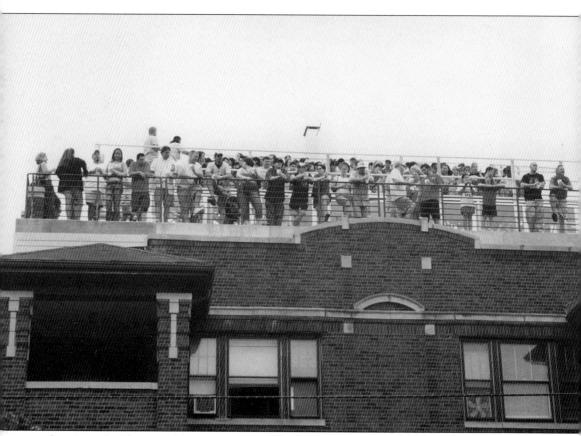

Owning a building in close proximity to Wrigley posed an issue during the late 1980s and throughout the 1990s when several rooftop ball clubs formed to offer a rooftop view of games. The team had been involved in legal proceedings with the operators of the rooftop ticket businesses for copyright infringement because the games we watch are copyrighted and we're technically only allowed to watch if we pay for a license or ticket. It's a complicated issue, yet one that hasn't decreased the number of "rooftop vendors" in the surrounding area. (Photograph courtesy of author collection.)

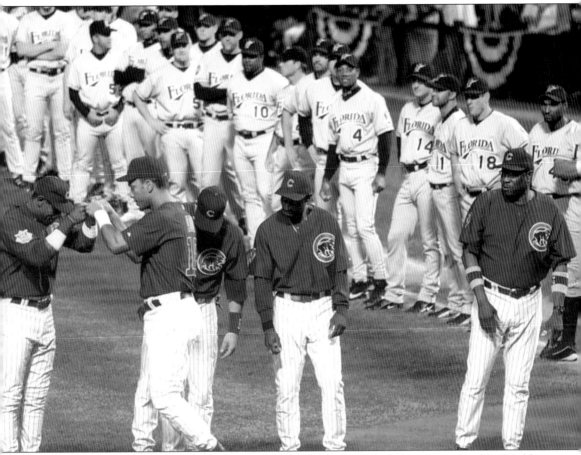

Controversy struck during the 2003 season when the Cubs inched closer to a possible World Series appearance. A foul ball, a zealous fan, and Moises Alou all made for speculative newspaper copy, but the Florida Marlins later went on to win the World Series. Here, in this photo, Sammy Sosa and Moises Alou share their enthusiasm and optimism before the first game with the Marlins. (Photograph courtesy of Steven Schwab.)

The intensity of the cross town rivalry between north side and south side may equal that of the Union and Confederacy. Although Chicago is politically a one-party town, it is a two-team town as far as baseball is concerned. And often, those taking the side of neutrality are looked upon with even greater scorn by fans of both the Cubs and the White Sox. Here, vendor Santos Villareal capitalizes on the rivalry with a special brand of Sox shirt, reserved exclusively for the diehard Cubs' fan. (Photograph courtesy of author collection.)

SEVEN

Wrigleyville

What a beautiful ballyard...I wouldn't be surprised if they're standing at attention in their apartments, too, during the Anthem and the stretch. The neighborhood is part of the game and the game is part of the neighborhood.
Keith Hernandez
If at First, 1986

There are no references to "Wrigleyville" in the history books.

Furthermore, no evidence exists of either William or P.K. Wrigley christening the immediate neighborhood surrounding the park with their surname.

But Lakeview—sometimes referred to as East Lakeview in real estate ads—is now the stuff of money and investment. These northside environs so close to the Lake are no longer perceived as a marginalized area to be looked down on, as they were in Weeghman's day. Bars, restaurants, rehabbed apartments, and the other ingredients that flavor urban gentrification have made this pocket of real estate fashionable for young, hip professionals seeking a lifestyle in just such a vintage neighborhood. Wrigleyville is nomenclature, a nickname . . . you won't find the name listed on any map, but the conclusions about where the boundaries begin and end differ strongly, depending on whom you ask. . . .

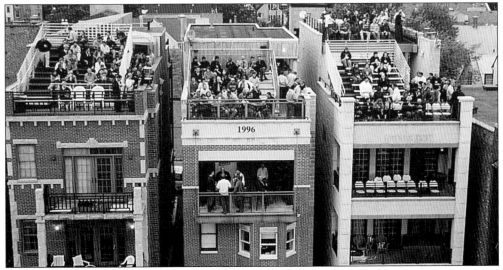

Rooftop baseball exploded in the neighborhood over the last decade. Patrons sometimes pay more for a seat in the special "club" atmosphere provided by a rooftop than they would for a seat behind first base. (Photograph courtesy of author collection.)

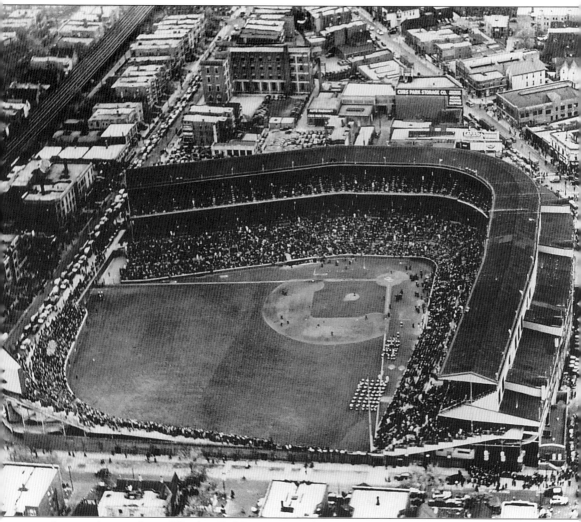

An aerial view shows Wrigley Field as it existed c. 1930. (Photograph courtesy of author collection.)

Today, the local businesses surrounding Wrigley Field are highly supportive of the Cubs and the revenue brought in by fans patronizing the establishments. The relationship between owners and consumers has been cemented by a general love for the area. (Photographs courtesy of author collection.)

Pictured above is an advertisement that was popular on the elevated, or "el," platforms more than half a century ago. (Photograph courtesy of author collection.)

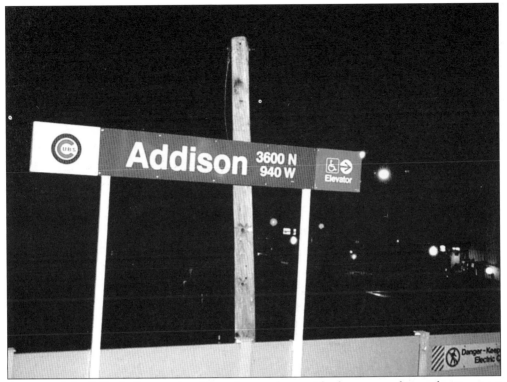

A view of the "el" platform today (above) . . . along with the eye-catching advertisement (below) that currently greets transit commuters. (Photographs courtesy of author collection.)

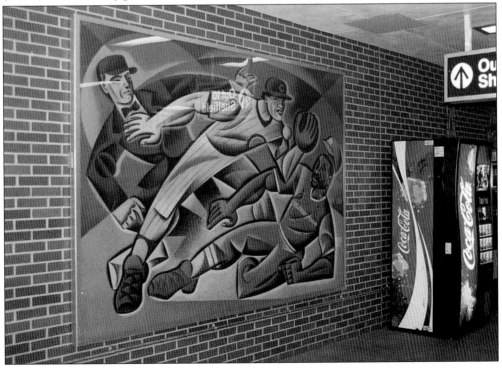

One option for living space: pictured above is a typical brick two-flat in which rent for one person averages $500 per month, not including utilities. The "For Rent" sign on the door boasted of a spacious first floor, 3-bedroom, 2-bath apartment with hardwood floors and a large kitchen. Parking in the area is catch-as-catch-can, unless a renter is willing to rent a garage for an additional $100 or more per month. (Photograph courtesy of author collection.)

A second option for living space can be found in the new condominiums that are springing up throughout the neighborhood. This Kenmore Avenue rehab offers narrow, yet deeper, living space than many of the pre-existing buildings which offered two or three rental units. (Photograph courtesy of author collection.)

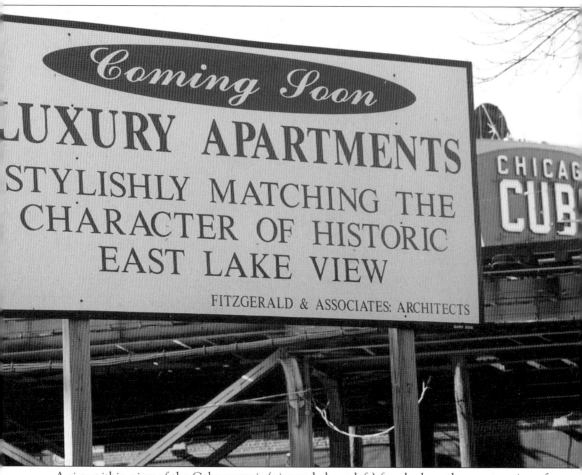

A sign within view of the Cubs marquis (pictured above left) foreshadows the construction of "luxury apartments" on a now-empty lot (pictured above right). Note the use of the appealing phrase, *"Historic East Lake View."* (Photographs courtesy of author collection.)

383 is a coveted number in Wrigleyville. And parking regulations are vehemently enforced as evidenced by the vehicle pictured below: three tickets, the boot, and a nasty note... (Photographs courtesy of author collection.)

For some fans, parking within steps of the Bleacher entrance is worth the cost of one or two tickets. Note the vehicles pictured in the background behind the crossing pedestrians. For neighborhood residents with vehicles (pictured below), the struggle to find evening parking proves equally, if not more frustrating than for non-residents. (Photographs courtesy of author collection.)

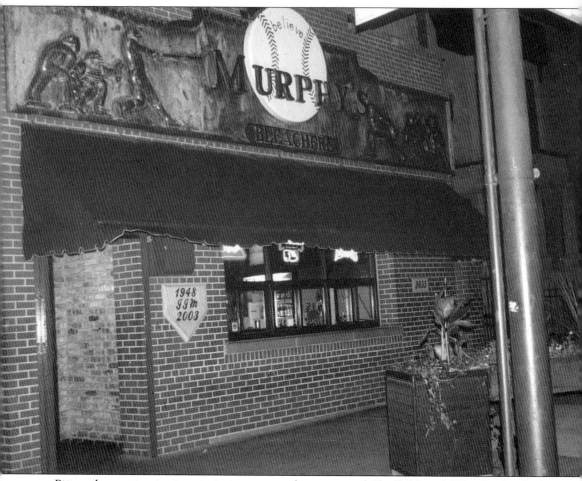

Pictured opposite is an evening scene at the corner of Sheffield and Waveland, which houses the ever-popular Murphy's Bleachers (above). The sound of the elevated train in the background can serve as a comfortable distraction while enjoying a post-game drink with friends. (Photographs courtesy of author collection)

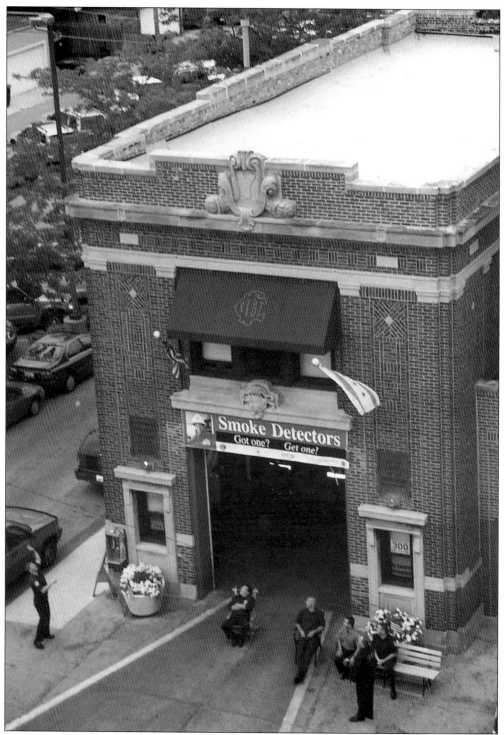

Engine Company 78 and Ambulance 6, located at the corner of Waveland and Seminary, has served city residents for over 100 years, and ranks as one of the busiest engine companies in the city. (Photographs courtesy of author collection.)

118

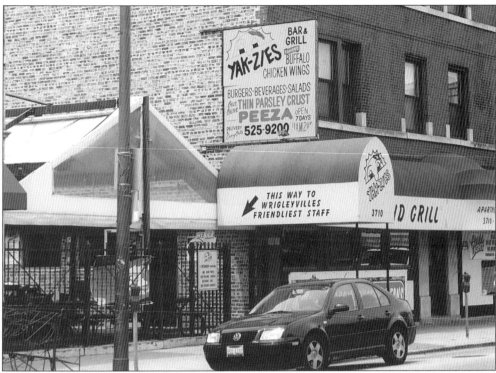

The Sports Corner (pictured at left), Yak-Zies, and Casey Moran's are three neighborhood watering holes with standing-room only before and after each game. Fans in search of a tavern aren't often disappointed because of the variety of choices available to them. (Photographs courtesy of author collection.)

The Metro, located at 3730 North Clark Street, presents loud local and international bands in a rather intimate venue. Formerly known as the Cabaret Metro, the concert hall offers some of the best live music in Chicago and was the starting point for Smashing Pumpkins, Ministry, and many others. (Photographs courtesy of author collection.)

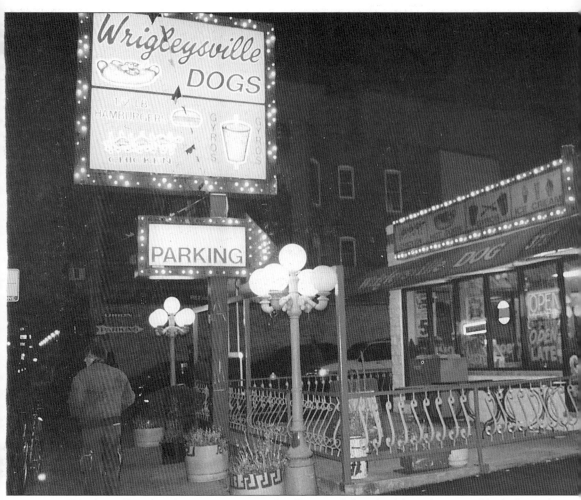

Wrigleysville Dogs (no, it's not a typo) offers good fast food less than one block from the ballpark. And they're open late. (Photograph courtesy of author collection.)

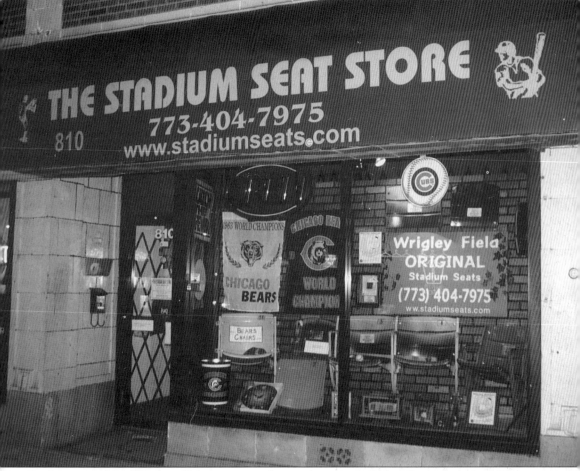

Farther away from Wrigleyville's parameters but within reasonable walking distance is The Stadium Seat Store, which specializes in selling old stadium seats—including some from Wrigley Field. An authentic single field box seat costs $300 and higher. A double seat can be purchased for $400 and higher. An authentic Wrigley Field brick retails for $99.95. (Photograph courtesy of author collection.)

A local real estate office keeps a running Cubs countdown until Opening Day. Such scenes seem to help pass the time, even making gridlock more bearable. (Photograph courtesy of author collection.)

A neighborhood sidewalk within five blocks of Wrigley bears permanent evidence of fan loyalty. (Photograph courtesy of author collection.)

The ancient gargoyle was said to be a symbol of the juxtaposition or balance of ugliness against the beauty inside the building it protected. Perhaps in relating this symbol to Chicago's Wrigley Field, we can conclude that this symbol will help us balance the occasional ugliness prevalent in the city with the pure, unadulterated beauty provided by an afternoon inside the Friendly Confines. (Photographs courtesy of author collection.)

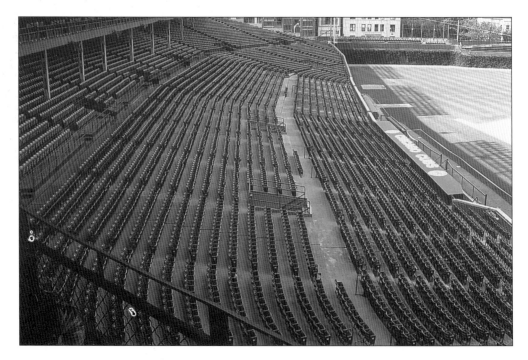